PROFESSIONAL
MARKETING & SELLING
TECHNIQUES
FOR WEDDING
PHOTOGRAPHERS

Jeff Hawkins and Kathleen Hawkins

AMHERST MEDIA, INC. ■ BUFFALO, NY

▨ Dedication

This book is dedicated to our friends and family who have inspired us, to our bridal couples who have hired us, to our employees who help us, and to our mentors who have helped educate us. A special thanks goes out to each and every one of you!

▨ Special Thanks

We would also like to take a moment and express our thanks and gratitude to the following people for contributing to this book.

Dan Chuparkoff, software developer and website designer

Charles & Janet McDonald, and Christine Perry-Burke

Art Leather/Gross National Product

Christina Smith, publisher of Orlando Perfect Wedding Guide

To all of our past bridal couples who are represented in this book

Copyright ©2001 by Jeff Hawkins and Kathleen Hawkins.
All photographs by Jeff Hawkins, unless otherwise noted.
All rights reserved.

Published by:
Amherst Media, Inc.
P.O. Box 586
Buffalo, N.Y. 14226
Fax: 716-874-4508
www.AmherstMedia.com

Publisher: Craig Alesse
Senior Editor/Production Manager: Michelle Perkins
Assistant Editor: Barbara A. Lynch-Johnt

ISBN: 1-58428-053-0
Library of Congress Card Catalog Number: 00-135903

Printed in Korea.
10 9 8 7 6 5 4 3 2 1

TABLE OF CONTENTS

CREATING YOUR GOAL

PHOTOGRAPHY IS AN ART. It is a rare art form and a talent that many desire, but only few possess. However, successful wedding photography is about more than just cameras and creativity. There is another art involved with being a wedding photographer; the art of successful business and marketing strategies. A photographer with mediocre talents and an incredible marketing and business structure can often become a success. Likewise, a fabulous photographer with an undesirable business plan and unappealing marketing structure may not survive in the marketplace.

This book explores the avenues an amateur photographer can travel to achieve success, and embark upon the path from hobby to career. We will also explore the steps required to enhance the journey—and success—of a professional photographer.

Creating Your Goal

Once you have elected to pursue the field of wedding photography, you still must identify your marketing demographics, and ways to reach the clients you want. First, come up with a plan and a goal. If you don't know where you are going there is no way to get there. Envisioning the plan can create passion, energy and make you excited about working to achieve your goal.

It is vital to create a clear vision. We have all heard the saying, "If you see it, you can believe it." While it may be a cliché, it also happens to be absolutely true. Envisioning yourself as successful will help make it happen.

Successful wedding photography is about more than just cameras and creativity.

When creating your plan, consider the following guidelines to make tracking your progress easier:

Commit 100% to the Goal—As long as you feel as though there may be an out (or an easy contingency plan), you will never truly reach success. Eliminate the thought of returning to the "hobby photographer" category. Plans should be long-range and mapped out for a lifetime and beyond. Have a destination for your business. Create goals for the next 5, 10, 15, 20, and 50 years. Who will be taking over your business? What legacy will you pass on?

State Your Goal in Writing—Begin from the future and work your way back. Start with your long-range goals. Let go and dream. Where would you like to be 20 years from now? What do you have to do to get there? Think in detail about how things will be different when you have

Envisioning your plans can create passion and make you excited about capturing all the little details on your clients' special day.

achieved your goals. See every detail clearly. Be able to feel, touch, hear, taste and do it! Once you have a long-range goal in mind, work backwards until you have it down to a plan that begins *today*. This will help you begin to make good choices about your future and business. Writing out your plan will also help you uncover any problematic assumptions or hidden obstacles you may inadvertently be creating for your business.

Create a Business Timeline—Without a timeline, you have simply created a wish list. Once you have defined the essential tasks necessary to reaching your goals, setting a time as to when you will do them makes all the difference. A timeline will allow you to measure your progress and keep you from being sidetracked. This is especially important for photographers, who often find it easier to get caught up in the artistic, rather than business, aspects of their work. A timeline will keep you focused on your goal and prevent you from spending hours dabbling with a photo-manipulation software program without a true destination or goal.

Do Not be Afraid to Take Action—A business plan can be very powerful. However, taking action is crucial. Do not be afraid to begin the process even before your plan is complete. Detail-oriented photographers may often chose to wait until everything is perfect before stepping forward, but keep in mind that not all the traffic lights will be green on the journey to success. It is important to begin moving forward with caution and critical-thinking skills, even while the light is still yellow. It is the passion and desire to reach your identified goal that will help guide you through all the intersections.

Tell Everyone You Know—Start talking about your plan, your dream, your wishes, and your intentions. Talk about it to your family, your friends, and business associates. Talk about it like it will happen and your subconscious mind will help you make it come true. The more you speak about your goals, the more real they become.

✦ Three Goals that I Want to Achieve Are...

In order of their importance to you, list three goals below. Then use the fifteen-point checklist to evaluate the goals, and provide incentive to achieve them.

1. _____

2. _____

3. _____

1. Do you want it badly?
2. Does this conflict with anything else?
3. Would my family approve?
4. Is it positive?
5. Is it realistic?
6. Did you express it in detail?
7. Is the goal high enough?
8. Do you have the personality qualities needed to achieve it?
9. What short- and long-range qualities are needed?
10. Is it written down?
11. Can you make a chart to check your progress?
12. Always think positively about yourself and your goal.
13. Use a self-reward program.
14. Be prepared for highs and lows.
15. Fill each moment with meaningful action.

Do Not Forget Your Plan—Businesspeople generally rely on a plan when their business is either starting out or suffering—but they often forget about it once they reach success. A key factor to a successful plan is remembering that it exists. Reevaluate your goals on a monthly basis and create a daily "things-to-do" list. List your goals in a notebook, or on an index card, put them on your refrigerator, or engrave them on a gold plaque. Do whatever it takes it make the plan work for you.

Successful wedding photographers know how to combine goal setting and business planning with high quality photography.

With an open mind, an "abundance mentality," and a business plan, we will examine the full-circle concept of wedding photography. First, we will identify your target market. Next, we will discover the difference working full-circle makes. Finally, we will reveal the hidden secrets to completing the cycle, while upping your sales by thousands of dollars.

TARGET YOUR MARKET

EVERY DAY OF EVERY YEAR, hundreds of couples begin to make their dreams come true by saying the special words "I Do." These couples vary greatly and in many ways—from their financial classifications and national origins, to their age specifications. In order to identify what demographic would be most productive and appropriate to target, photographers must identify their ideal markets. This classification establishes how the photographer will position him or herself in the community in regards to pricing structure and location. The first step is to clearly define what product you want to produce, who you want to produce this product for, and how you want to promote this product.

▨ Producing the Product

We have already established that your primary objective is to target the wedding industry. However, there are different types of products to consider within that industry. For instance, wedding albums range widely in style and size. Your company may also choose to provide a variety of framing options or invitation pieces.

Selecting the types of products you choose to produce is partly dependent on the type of image you choose to create. There are a wide variety of styles of photographic coverage, ranging from traditional to photojournalistic—and even "faux-journalism," the term recently coined by Denis Reggie for a new subfield. While a combination of all three of these styles may be used, your market will typically associate your organization with the

Selecting the types of products you chose to produce will begin with the type of image you chose to create.

10

Traditional images, like the pair at the top of this page, reflect only one of of the many styles of wedding photography you may choose to provide to your clients. Images in the photojournalistic style, like the images directly above, are extremely popular among both photographers and their clients.

Photojournalism (above) and "faux-journalism" (left and opposite page) are two related, less formal styles of wedding portraiture.

one you favor most. The style you become passionate about should be the one you promote the most strongly.

A good starting point for learning about the types of products offered by professional wedding photographers is to contact your local branch of the Professional Photographers of America (PPA) or the Wedding and Portrait Photographers International (WPPI). Contact them not only for additional training and for education in regard to the different products available, but also to register to attend the annual conventions and trade show exhibits sponsored by these organizations. The vendors at these shows can introduce you to new products and help you select what products will work best for your organization. Having all the major vendors under one roof can make your search much easier—as well as more time efficient and enjoyable.

Selecting products to sell and display must become an ongoing process and part of your long-term business plan. Keep your displays fresh, and work to eliminate any items that look dated. Even though time and money has been spent on these, each year styles and demands change greatly. Stay on top of the latest trends. Read bridal publications to see what they are promoting to your market, and follow their lead. Brides pay attention to these magazines, and will seek out similar styles for their own weddings.

◈ Defining Your Client

The type of products you ultimately select will begin to define the type of client you will attract. For example, more contemporary work, such as black and white photojournalism, often appeals more to a younger demographic. Unless you are content to attract only a very small demographic, though, your product will need to be more diverse. The safest marketing route is to select not only the products that most appeal to you personally, but also a selection of products and images that are designed to appeal to a people with a variety of tastes. Showing the full breadth of your style and products will make doing business with you attractive to more clients, while allowing you to maintain your identity.

Keep in mind that there is no right or wrong way to establish your demographic. The choice will be based on the styles you prefer to produce, the area in which you do business, and the people you want to work with. Is your style more contemporary or traditional? Do you live in an urban center or a small seaside town?

Production volume is another area to evaluate. Many very talented photographers target the steady stream of lower-budget weddings, and seek a high volume of production in this area. Some photographers choose to seek out a few very upscale weddings. Their production volume may be lower, but they achieve higher returns on each individual wedding. Other

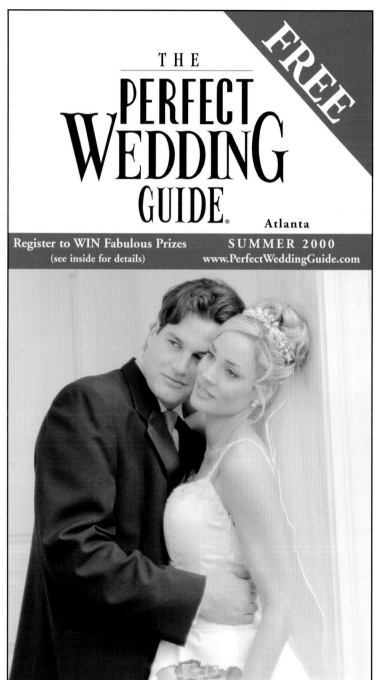

Reading bridal publications will help you remain up to date with trends in the field. (Photo by Jeff Hawkins, cover courtesy of The Perfect Wedding Guide*)*

businesses fall in between the two extremes. How many weddings are you willing to photograph in a year? How much do you need to earn per wedding to meet your financial goals?

As you ask yourself these questions, compare your answers to your long-term marketing plan. Doing this will allow you to establish the client demographic that would be most appropriate for your studio. This classification will determine your promotional strategies.

❂ Beginning Your Promotions

The types of weddings you desire to solicit and the client you wish to target will determine the most desirable location for your studio, the advertising required to attract your demographic, and the pricing position you will require to remain competitive.

High Volume, Low Budget—Photographers who chose the higher volume of lower-budget weddings will generally want to select a high-traffic, lower-cost location. Since location appeal is not as crucial to this type of client as to very upscale clients, positioning the business for visibility is more important than investing in a "prestige" address. Furthermore, photographers who seek out this demographic can also utilize smaller advertising means, such as business card advertisements or classified advertisements. In addition, the Yellow Pages are a good means of advertising for this type of photographer, because the client is typically shopping for price, not style. This type of coverage is often very successful in destination-wedding locations such as Hawaii, Florida, Las Vegas, etc.

As a word of caution—new photographers often begin their business by targeting this market in order to receive name recognition and attain a target audience. However, bear in mind that it can be difficult to escape the status and recognition you receive in this category and, through time, this high volume workload may become very tiring and mundane.

Furthermore, even though this type of service usually requires a lower budget, photographers should never give away their work! The pricing structure you establish affects the entire photography industry and the perception of photography in general. Your pricing structure correlates with your level of competency and your self-esteem. Ultimately, the price you place on your work reflects the way you view it.

Low Volume, High Budget—Photographers who chose to target a higher class clientele and lower volume of weddings typically need to increase their liabilities to target this market. This type of photographer has two choices in regards to location: he may select to work in either an upscale commercial location or in a residential gallery. In our own work, the residential gallery is the avenue that we have found to be most feasible and efficient.

✵ Residential vs. Commercial

When deciding between a residential gallery and a commercial property, you should consider the following guidelines:

RESIDENTIAL GALLERY

A residential gallery is a business you run out of a your home (or another home).

DO

1. Examine the location. Typically, a subdivision is not appealing to upscale clients—unless it is *extremely* upscale. The residence should be located near a main road and be easy to find.

2. Rather than working your gallery into your home, select a home that fits around your gallery. Consider your business needs when buying a house.

3. Purchase a home with either a separate entrance, a mother-in-law addition, or a large enough walk-in space to give clients the impression that they have entered a professional gallery.

4. Purchase a home/gallery in a location that allows for environmental portraits (engagement sessions, family portraits, etc.).

5. Invest a portion of the revenue you are saving (by utilizing a residential gallery versus a commercial facility) on advertising to make up for the loss in exposure. Make them come to you!

DON'T

1. Set up a residential gallery if you can't keep your family separate from your business. Children and pets can be a distracting and are a turn-off to many people.

2. Allow for havoc and clutter in your gallery. Design your home to meet a level of professionalism and create a first-class impression with your clients.

3. Allow family members to answer your office line in an unprofessional manner.

4. Forget that you do not get a second chance to make a first impression. Even though you are not "going to work," your wardrobe should convey that you are a working professional.

5. Work seven days per week, 24 hours a day. Do not allow yourself to burn out. Establish set office hours. Your family will respect your business, if you respect your family.

COMMERCIAL FACILITY

A commercial facility is typically in a mainstream business location with high visibility.

DO

1. Plan to spend a lot of money for a first-class professional facility.

2. Invest in elegant décor.

3. Schedule specific office hours.

4. Invest in property and liability insurance.

5. Consider how easily directions can be given, and if possible traffic congestion in entering your location will deter clients.

DON'T

1. Let your family suffer long-term to maintain the caliber of your studio image. Remember why you began this goal and what your priorities are.

2. Invest money in a commercial facility for public exposure and then leave it unattended. Hire a marketing representative to maintain the image you began.

The second set of liabilities involved for a photographer who wishes to target a higher-budget wedding involves advertising. The number one objective for this class of photographer is to get their images into the community. This can be done through advertising in specific wedding publications, networking with other vendors and Internet marketing. Yellow Page advertisements are not typically a draw for this target audience.

Combination Volume, Combination Budget—The last type of business style is the classification that falls in between these two extremes (high volume/low budget, and low volume/high budget). This type of business makes up the majority of the photographic enterprises in this industry. These photographers usually examine the pricing strategies of the upscale photographers, then place themselves just below those photographers' lowest range. They provide competitive pricing, and a level of service that surpasses the quick production-line feeling of the lower-budget wedding photographers.

These businesses can utilize a combination of advertising styles and locations, depending upon which end of the spectrum they chose to target. In addition to the possibility of utilizing a commercial facility or a residential gallery, they may be able to consider other location alternatives to reduce overhead costs. A good starting point for exploring your options for this type of business is to network with other vendors in the wedding industry. Consider teaming up and sharing a facility with one of them. Alternately, consider renting out just a conference area to be used to meet with clients. While all other business can be conducted from your home, this may give you the professional presentation you need, with minimal overhead required.

A good starting point for exploring your options for this type of business is to network with other vendors in the wedding industry.

EFFECTIVE ADVERTISING

HOW DO YOU ACHIEVE NAME RECOGNITION? How do you make your phones ring? How do you get your name on vendor referral lists? What steps can you take toward getting your work displayed in bridal shops, flower shops and with other affiliates in the wedding industry?

These questions are beneficial to ask, and must be thoroughly answered in order to promote your business within the wedding industry. In this section, we will explore several successful promotional strategies, from marketing your business via networking, bridal shows, and Internet access, to publication advertising.

Networking

Networking is a powerful tool. While it can be a social enterprise, it is also the most cost-effective form of promoting your business. You can begin networking immediately. Here are some helpful techniques that can be used to begin your marketing journey.

Introduce Yourself to Other Wedding Vendors—Keep in mind that your image is crucial. Many vendors will gauge your qualifications as a photographer based upon your appearance alone. Dress for success, and dress for where you *want to be,* not for where you are right now. Just because certain attire may be viewed as acceptable in the *photography* industry, when networking with people from other fields in the wedding industry there may be different expectations. The best approach in selecting networking attire

How

do you

achieve name

recognition?

How

do you

make your

phones ring?

is to attempt to dress a step or two above the vendors with whom you are meeting.

Plan to Meet New Vendors—Create a list of vendors you would aspire to work with. You can compile this list by retrieving information from wedding publications, networking organizations, or even the phone book. However, be careful not to become overwhelmed with the number of people and the number of possibilities. Set a goal to contact three new people each week, and plan strategies for developing profitable new relationships with them.

Join an Organization—Consider joining a networking organization. Many areas have organizations specifically for wedding professionals, for example, The Wedding Professionals of Central Florida (WPCF). Also, the National Association of Catering Executives (NACE), or the American Bridal Consultant Association (ABC), or even your local Chamber of Commerce have a variety of lead groups and affiliate positions that may be profitable. Remember, just joining the organization is not profitable. You must begin donating time and taking an active role. If you are pressed for time, consider selecting only one group to be involved in, then consider volunteering on its Board. The more involved you become in the organization, the more likely other members will refer you. As you take on a more authoritative role, you will begin to be viewed as more professional, reliable, and stable. People want to refer people they know they can count on, and whom their brides can depend on.

Maintaining a positive attitude is everything. This young wedding-goer may need to work on that!

Find a Mentor—A photography mentor can be viewed as an advisor or a coach. Maybe it is someone who has an established business, who is viewed as a master photographer or who has experience with judging print competition. A mentor can educate you not only by example, but also by giving you many pointers for promoting your business. Observe how she promotes her business and watch her behaviors. Learn from her experience and success. You may also be able to develop an effective referral program with other local photographers who have noncompetitive spirits. Often, a mentor can also refer to you couples who don't fit her demographic, or who are looking for a photographer for a date on which she is already booked. Don't be afraid to ask for assistance! Most experienced photographers enjoy sharing their thoughts and expertise.

Follow Up with the People You Meet—Don't forget to add these new business associates to your vendor database. Everyone wears a sign that says "Make me feel special!," so make your meeting with them matter. Send them a thank-you note with a promotional packet after your first meeting. Extend an invitation to visit your gallery and review your portfolio. Also, remember to include them in your holiday promotions and make sure you follow up with them at least once a quarter. Get their e-mail addresses and add them to your e-mail list. It is very easy to send out quick updates on company promotions and specials—or even a simple holiday greeting. Do not let them forget you!

Keep a Positive Attitude—Your attitude affects the people you associate with. Nobody likes to be around someone with a negative attitude, so stay positive. Affirm what you want and visualize getting it. An affirmation is a statement that visualizes what you desire. Visualize being on the top of catering director's referral lists. You may just end up there!

▨ Successful On-Line Marketing

How does a photographer capitalize on the rapid expansion of e-commerce, and the popularity and effectiveness of an Internet presence?

Let's begin with a typical example. Let's pretend for a moment that somewhere there is a small wedding photography company. The business owners would definitely want to create a website, because not having one would be negatively impact their image and reputation, right? So the proprietors diligently create a small web page with their company name on it, complete with address and phone number. The page might even contain a picture of the crew donning an array of appropriate formal attire with all their equipment close at hand. Most small (and some large) company websites look just like the one described here. They need to select a name for

> It is very easy to send out quick updates on company promotions and specials or even a simple holiday greeting.

the website and it just so happens that <www.GetWeddingPhotos.com> is available, so they register this name as their new website address.

Now, for a moment, imagine a young bride in need of a wedding photographer in her own metropolitan area. Unsure where to begin her search, she turns to the web. An experienced web surfer, she knows to first head to a popular search engine and type in a few words to get her started. She chooses "wedding" and "photographer" (try this yourself). Fortunately for the small company above, these words appear on the web page that they hastily designed, but according to the search engine, those same words also appear on about 38,300 other web pages. <www.GetWeddingPhotos.com> is somewhere on that list of 38,300.

With a lot of luck, and some skillful application of key words (called metatags) that explicitly describe the site's content, it might even appear somewhere in the first 2000 entries. Assuming our bride had the patience to go through several hundred different options, she would quickly find that the majority of these websites were for photographers who lived and worked in other states. The moral of the story? Just because you put a website on the Internet does not mean that anyone will ever find it!

Well, our hypothetical wedding photography company learns quickly from its mistakes. In an attempt to solve their "lost website" problem, they

Just because you put a website on the Internet does not mean that anyone will ever find it!

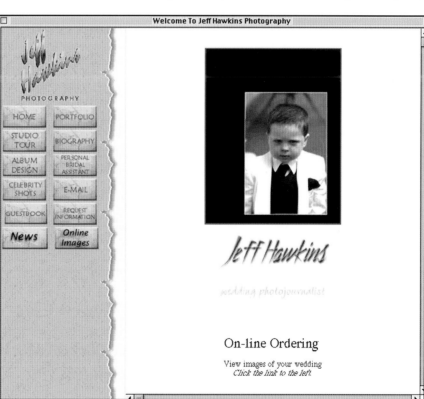

The popularity and effectiveness of your Internet presence depends on some solid planning and marketing.

opt to place their web address on their business cards and correspondence, so that people can easily get to <www.GetWeddingPhotos.com>. This is certainly something you should do—it's a great idea. Don't embarrass yourself, however, by handing out a business card featuring your website address, and then having a potential customer go to your site to find only a one-page site with basic contact information (name, address, phone, etc.). That information was already on your business card. You just wasted their time and they will repay you by taking their business elsewhere.

According to Dan Chuparkoff, an experienced software developer and website designer, there are five simple "P.I.E.C.E.s" to creating a successful Internet site:

Purpose—Define the purpose of the site.
Identity—Determine a name for the site.
Essence—Choose the content's depth and the frequency
of changes.
Creation—Design the site with an experienced consultative
web designer.
Enlighten—Begin to advertise and to attract people to your site.

Purpose—The most common mistake made by business owners during website construction is that the purpose of the website is incorrectly gauged. The first question to ask yourself when creating a website is, *"What is the purpose of my website?"* Whatever your product may be, the answer to this question is, *"To get customers."*

That much is simple, but it is easy to overlook the fact that the task of acquiring customers is broken up into two stages. These two stages are commonly referred to as *advertising* and *sales*. This may seem elementary, but failure to make this distinction is the most common mistake made in business website development. Making this mistake will lead to wasted money and frustrated customers. The goal of advertising is, naturally, to somehow grab the attention of your potential customers. The goal of sales is, of course, to persuade these potential customers that your product is the best of all the available options. Which of these roles would a website service? Most people answer this question incorrectly.

A website is *not* an advertising vehicle. Instead, a website should be used as a tool to aid in the closing of a sale. There are many ways to draw people to your website, and some of them will be described in the following paragraphs. This having been said, however, the assumption must be made that there has been some previous interaction between you (or a representative) and viewers of your website. There will be a few exceptions to this rule—people who live in your town and want your services, who coincidentally type in exactly the right key words and stumble upon your

The most common mistake made by business owners during website construction is that the purpose of a website is incorrectly gauged.

Internet doorway, for example. As search engines on the web evolve, and people become more experienced at performing searches, browsers will become more successful at finding what they are looking for. Unfortunately, as things are, you cannot rely on attracting users in this way. Viewers will most likely have decided to browse your site after:

1. Meeting with you and following your suggestion to check out the site.
2. Viewing an advertisement in a publication or on another website.
3. Making contact with a satisfied customer that recommended your services.

So, whether you design your site yourself or commission a web designer to the task, your site's purpose should be clearly defined before you begin creating pages. At the very least, provide examples of your work or let visitors view a calendar of your availability. Ideally, your website should contain a completely painless way for visitors to purchase your product or register for your services while browsing the pages that you have provided to them. Use your website to give your prospective customers information that gets you closer to a sale.

Identity—The next step in jumping on the e-commerce bandwagon is coming up with a skillfully chosen name for your website. This is commonly referred to as your "domain name." The most obvious choice for a domain name is one that matches your existing company name. You can find out if a specific domain name is available by going to the website of an accredited registration service. There is a list of accredited services available at <www.Internic.net>. One of these registration services is <www.Register.com>. Try surfing over to the Register.com site to see if your own business name is available. If your business name is a registered trade name, and it is already held by someone else as a domain name, you may have legal rights to that domain name. You may dispute such conflicts in a manner similar to disputing other trade name violations.

If your first choice of names is unavailable, remember these tips when choosing a different name:

1. You may only use letters, numbers, and the hyphen character (-).
2. Avoid the use of homophones ("by" and "buy," "for" and "four"). These add confusion when passing the site's name along through word-of-mouth.
3. Keep in mind your company's future growth when choosing a site name. The name <www.JeffHawkins

Use your website to give your prospective customers information that gets you closer to a sale.

Photography.com> is a good name for a wedding photojournalist's site, but it would become slightly less suitable if used to promote the other consultative wedding services provided by the same business.

4. Somewhere near 99% of the words in the English language are already taken, so don't expect your first choice to be available. Be prepared to spend some time looking for a name that isn't already registered.

Essence—Here the task becomes more difficult. Determining the depth of your Internet presence can be more important than time spent on design and style. A prospective customer's visit to your website will generally be their second instance of exposure to your company (the first having been an introduction via an advertisement or a personal endorsement of some kind).

Each time you require your target customer to spend time and energy to interact with you, a few more people will get bored, distracted, or will be somehow motivated to go elsewhere. It is important to make sure that your site isn't an added stage in your selling process, without a clear benefit to the customer. Before you had a website, prospective clients would typically see your ad in a publication and be prompted to call you. The last thing you want to do is run an ad that instructs the user to check out your website, and then have your website do little more than prompt the user to give you a call for more information.

Create a website that works to bring prospective clients a little closer to buying your product or service. The most important thing to browsers of the Internet is immediate gratification. People want information immediately. They don't want to wait to meet with you to find answers to their questions. Give viewers of your website as much as you can possibly provide them. If you have ever received a request from a customer for your portfolio, your biography, or your references, then put these things on your site. If your website has convinced them that your service is the one for them, provide them with the opportunity to purchase or register for your services. This removes the opportunity for them to change their minds while they wait for your e-mail response or scheduled appointment.

As previously suggested, creating an on-line ordering system is indisputably the best way to profitably capitalize on the flow of traffic onto your site. For example, you can offer a program to your customers charging them a fee to place their proofs on-line. This will allow them and their friends and family from around the world to see the proofs, and directly order images. Set a specific price for engagement proofs on-line, and an additional price for wedding images. We also suggest having the number of images, the selection of prints, and the length of on-line visibility selected

If you have ever received a request from a customer for your portfolio, your biography, or your references, then put these things on your site.

at the discretion of the photographer. Thus, you can select what is displayed, how long it is displayed, and how much it costs. For more information on on-line ordering, try contacting <www.morephotos.com>. The cost is minimal and the response can be incredible.

Creation—In most cases, you will want the help of a consultative web designer to create an effective Internet presence that results in a positive user-experience and, more importantly, in increased sales. If you want to take a stab at it yourself, though, there are many tools available (such as Microsoft's FrontPage®) that will allow you to create and design a website on your own. In order to add some of the really productive components, like on-line ordering, on-line registration, or an automated response system, you will probably benefit from at least consulting an experienced Internet professional. Enlisting the help of a designer will also save you from the pressure of trying to register your own domain name and from trying to find a site-hosting service.

Choosing a web designer is a difficult task that may take several attempts. Depending on the depth of your site's content and the frequency of its changes, the fee for this service can range from just a few hundred dollars to several thousand. If you don't have the benefit of a personal referral, the quickest way to find a web designer is by consulting your local Yellow Pages. A slightly better way is to use a search engine like <www.Yahoo.com> and search for "web designer." Remember that it's not necessarily required that your designer live in the same city (or even country) as you. Contact with your site creator will most likely be conducted via e-mail and the Internet itself, anyway.

In the experience of professional web designer Dan Chuparkoff, these are the top things to consider when hiring an Internet site designer:

1. Look at his or her past work.
2. Have them create a low-cost prototype before committing to the entire project.
3. Discuss availability in the future to update information as it changes.
4. Get quotes from several different designers (they will vary dramatically).

When designing (or when helping to design) your website, keep in mind that a well-planned, easy to navigate website is crucial to creating a pleasant user experience. Keep it simple, using typical web standards and conventions. Only use underlined text, for instance, if that text is a link to another page. Users of the Internet have been conditioned to expect certain things to happen. Capitalize on this fact. People know that when they see a tiny picture (commonly called a "thumbnail"), they can click that

Choosing a web designer is a difficult task that may take several attempts.

thumbnail to see that same picture in a larger form. Keep these conventions in mind, but don't compromise your style and expression. Just as you would "dress for success," when meeting with a prospective client, your website should communicate exactly what your own professional appearance would have conveyed to the client in a face-to-face meeting.

Furthermore, remember that images are very important. Bridal couples are visiting your website to see your gallery and view your images. Excessive wording or a cluttered page will quickly bore the reader. Replace excessive wording with the images you choose to promote. Keep in mind that not everyone viewing your site has a modem or a computer that is as fast as yours. Always provide thumbnails to any large images on your site. This will considerably shorten the time it takes for your pages to load.

When you are finally finished with your site's creation, test it on the slowest computer you can find, and with different web browsers. Try to determine if your prospective client would have been patient enough to wait for the whole page to load, and make sure that it loads correctly on all major browsers.

Enlighten—Finally, you must spread the word that you have a website and let people know what the site's address is. After all, just because you *have* a website does not mean that everyone in the world will surf onto it.

Networking and word-of-mouth are still the most effective forms of advertising. Make sure you include your new web address in all of your promotional materials. Place your web address on all of your business cards and letterhead. Make sure you send e-mail messages out to everyone in your address book, informing your friends and family about your site. Also send notifications to the affiliates on your vendor list and consider adding a signature file to all of your e-mail notifications. For instance, add "Visit our website at <www.jeffhawkins.com>!" to the bottom of all your Internet correspondence.

When choosing where to advertise, watch your advertising dollars carefully. Take advantage of all the free links! These are links on related websites that promote your company. In some cases, you can submit your website (and possibly your work) and the partnering site will post your information at no charge. However, some sites negotiate a link-exchange. This is where you attach a link on your site, linking them to you and vice versa. We don't personally recommend link-exchange, simply because it sends the viewer away from the site rather than keeping them there.

Bridal Shows

Bridal shows can be coordinated as spectacular events. They are showcases of participating wedding vendors from varied locations. They gather together to share ideas and information, and to help each couple plan inti-

Make sure you send e-mail messages out to everyone in your address book, informing your friends and family about your site.

mate details about their special day. If you plan to participate in bridal shows, be selective about the events. These shows can become costly and time-consuming; they may also, however, be the most effective form of advertising for your company.

You can usually learn about upcoming shows from local wedding organizations or by reading area bridal publications. However, be aware that many of the bridal show coordinators limit the number of photographers able to participate. Review a copy of the *Bridal Publications* bridal show section as soon as the new book debuts. Contact the coordinators of the shows you wish to participate in, and verify the forms of media advertisement and the number of photographers able to participate. Then, determine when booth selection takes place and the cost involved. If everything meets your approval, place a deposit. Do not delay. Procrastination is never listed as a quality of successful people. Once you have agreed to participate, begin establishing your booth selection, your design and décor, and your method of marketing.

Bridal couples have an overwhelming selection to choose from at a bridal show—from cakes and gowns, to music and accessories. It is crucial to make your products and services stand out.

Booth Selection—When selecting your booth, attempt to be one of the first people to get to choose your location. Typically, booth selection is established based upon the registration dates and when deposits were submitted. Determine where the food stations and drink areas will be located. Position your booth in the midst of other popular vendors. Food is always a great highlight in a bridal show arena, and creates a magnetic attraction. Most people want to experience the food and sample the cakes; therefore, their displays will draw more traffic to your area. However, apply caution to this selection. Do not get too close! Allow for a few booths to be placed in between, so the congestion does not deter people from visiting your booth and viewing your images. Positioning your company a few spaces in front of a catering facility or bakery will allow the prospective brides to browse a selection of your work while waiting in line. This also prevents potential problems with spilled fruit punch or sticky fingers doing damage to your sample albums.

Design and Décor—Once you have selected a booth location, begin developing your signature design and décor. Purchase a dolly and a carrying case to hold a cloth backdrop, tables, linens, electrical extension cords, lights to place above your framed images, extra pens, clipboards, table easels for your albums and any other items you chose to use for your display. Once you gather the materials essential for your display, the bridal show preparation process should become easier. As time goes by, you are not required to change the display as a whole; you will just update the images.

When selecting your design and décor, consider the message you are sending with what you select. Strive to create a balance and an even flow. Avoid standing behind a table. The table creates a barrier and is viewed as a defense mechanism. Instead, consider pushing the table up against the wall or requesting two classroom-style tables instead of one large table. Create an "L-shape" or a "T-shape" design within your booth. This will invite people to step inside. You will also be able to fit more people into your booth at one time, and display work samples and registration boards all around the table, rather than just in the front. Your goal is to attract people to your booth, not to give them reasons to keep walking. The more comfortable they feel the more likely they will be to see your images and register for more information.

Keep your décor elegant and simple. The majority of the people who attend bridal shows are women, therefore it is important that your booth appeal to the female market. However, do not overdo the wedding façade or décor. Too many vendors will have that décor and your objective is to stand out and look different. If the bridal show is supplying pipe and drape dividers between the booths, you may wish to hang a fabric backdrop up in place of the standard white background. An elegant black backdrop is always our personal favorite, but yours should be based on the style of your

Positioning your company a few spaces in front of a catering facility or bakery will allow the prospective brides to browse a selection of your work while waiting in line.

own work and décor. This will create a unique setting and will be more noticeable to the bridal couples attending. Additionally, you may wish to place material over the tables prior to setting up your album display.

If you are targeting the most upscale, big-budget brides, you may wish to invest in a double booth space. Double booths give you more room to work with, and communicate a successful image to your potential clients, as well as to other participating vendors. A double booth will also allow you to create an area for people to review your work, and an area to receive additional information or schedule consultations. When using the double booth approach, place a classroom table with your albums in the section closest to the entrance, and a round table for mini-consultations on the opposite side. Use the space in between to display your easels.

Regardless of your booth size, utilize a professional sign and a display of albums and images. Your sign is more noticeable when displayed higher, so attempt to hang it on your backdrop or determine how it can be attached to the wall. Do not purchase a vinyl sign or a sign that is larger than three feet long by one foot wide. You do not want your sign to detract from the elegance and style of your work. Secondly, select no more than three or four albums to display. The number of albums will be determined by the length and layout of your tables. Do not let your tables get overly crowded. Use tabletop easels to lift your albums up, thus allowing a wider number of prospective clients to view them at once.

Finally, place a variety of your favorite framed images on display. Select images you want to promote and that reflect your style. Pick prints that will intrigue the viewer—dangle a carrot, and make them want to see more. Do not give the impression that you are showing them every good image you have ever created. Purchase quality easels that can comfortably display two framed images at once. Do not display more than five or six images at a time. The number of display images will be determined by the amount of space you are working with. Do not become overzealous—adding too many images will only make the booth appear cluttered. To showcase your work as attractively as possible, take a portable lighting system to attach to your easels. Just don't forget to pack your extension cord!

Method of Marketing—With a logistically selected booth space, an elegant display, and effective marketing techniques, a good bridal show can result in a tremendous amount of business for your studio. Because bridal shows may literally have hundreds of brides in attendance, the more assistance you have, the more beneficial the show will be to your business. When promoting your business at a bridal show, consider contacting past bridal couples and asking them to work it with you. You may wish to reward them for their efforts with a custom-framed image from their day or a gift certificate for a family portrait session. Have them bring their wedding albums and share their experi-

Pick prints that will intrigue the viewer— dangle a carrot, and make them want to see more.

ences. Their opinions will often be more effective then anything you could possibly say. Do coach them not to give out too much essential information. Explain to them that every situation is different, and that their day should be discussed privately. Encourage them to have the brides register for more information.

Do not wait for an attendee list—get started right away on your leads. Remember, each bride will leave the show with a bag full of products and a brain full of mush. It will be extremely difficult for them to dig through all their literature and actually remember meeting with you. Therefore, it is imperative to create a contact or registration list. You can avoid requesting their mailing address, if you choose. Recording an address is tedious, and brides often have to write it over and over throughout the day. However, it is important to have them register with the following information:

Bridal Show 2001

Name:_____

Wedding Date:_____

E-mail Address:_____

Contact Phone Number: _____

_____ Yes, I would like to schedule an appointment to visit to your gallery.

Within 24 hours, jump-start your business. Verify which dates are currently available for visits, then send a group e-mail out to all of the prospects you met. Include your website address in your e-mail. The address will serve as a link to your website and make it easier for them to learn more about your company. It will eliminate the need for them to search for it on their own and the necessity of retyping it. Within 24 hours, enthusiastically call and schedule visits to your studio. Clients will not perceive your assertiveness as overzealous behavior, but rather as a courtesy call. Remember, they told you they wanted more information. You should *want* to give them a call before your appointments fill up and their date becomes booked. See page 46 for pointers on consultations.

In conclusion, remember that you never get a second chance to make a first impression. The little things you do will make a big difference.

Within 24 hours, enthusiastically call and schedule visits to your studio.

1. Your image counts. Look your very best!
2. Never chew gum or eat at your table.
3. Try to avoid sitting as much as possible, since sitting creates a passive and disinterested appearance.
4. Keep a positive attitude. Be friendly and courteous. Let

the brides do most of the talking. Ask open-ended questions. (See page 39 for tips.)

5. Stay in your booth. Do not chase people down. If they are interested, they will make eye contact. Read their body language.

6. Never talk negatively about another business or vendor in the wedding industry. Respect their differences and value healthy competition.

Publication Advertising

There are many wedding publications in this industry that can assist with getting your name out into the community. These publications have a variety of advertising options that may be profitable in creating community

One place where photographers can run print advertisements is The Perfect Wedding Guide. *(Photo by Jeff Hawkins, Ad design courtesy of* The Perfect Wedding Guide*)*

Thank you for considering Jeff Hawkins Photography. We look forward to sharing your special day with you and making your memories last a lifetime.

P.O. Box 151023
Altamonte Springs, FL 32715
407.834.8023

congratulations
on your
engagement

Jeff Hawkins
photography

w w w . j e f f h a w k i n s . c o m

start down
this one

Jeff Hawkins
photography

P.O. Box 151023
Altamonte Springs, FL 32715
407.834.8023

North St.

Palm Springs Dr.

Seminole Ave.

Frances Cir.

I-4

S.R. 436

located at
177 Frances Circle

Thank you for considering Jeff Hawkins Photography. We look forward to meeting with you on:

w w w . j e f f h a w k i n s . c o m

Before
you start down
this path...

Jeff Hawkins
photography

Promotional postcards don't require folding or sealing, and can be addressed with labels from your computer. They also require less postage than a letter, and allow you to show prospective clients another example of your work. This makes them an efficient way to reach contacts from a bridal show, or leads generated by an ad—or even to supply directions to your offices once an appointment has been made.

awareness. The type of publication and your marketing demographics will determine the size of your advertisement. Bear in mind that many publications will barter their services in exchange for your services. So, when selecting your advertisement, develop a good relationship with your sales representative and try to barter or negotiate a portion of your payment.

However, advertising alone is not the most effective use of your money. When you place ads, you'll also receive lead lists from those publications (leads generated by the publication via advertising, bridal shows, direct mail drops, etc.). Working the lists the publications provide you with is crucial. In these days of electronic media, it is very effective to request your leads via the Internet. To avoid having a large amount of leads and not enough time to effectively follow up with them, request that your leads be e-mailed to you on a weekly or bi-weekly basis. Next, delete the leads for the dates you are no longer available. The main information that you will need to print will include: name, address, e-mail address, and phone number. Narrow your listings, and print your document.

At that time, you should also prepare an e-mail and leave it in your draft folder. This should be an introductory letter and should include your website address. Including your website address will create a link for the prospects and make it easier for them to view your work. If you receive twenty leads or so a week, after deleting the dates you are not available, it should only take a matter of minutes to respond to your prospective clients. This places your company in front of most of your competition.

Lastly, use the printed lead list to address promotional postcards to be mailed to the clients who did not list their e-mail address. Promotional postcards are very efficient for this purpose since they don't require folding or sealing, and cost less to mail that a letter. They also offer more immediate impact (the bride doesn't have to open anything to see your message) and can show the bride another example of your photography.

We do not recommend purchasing the bulk direct-mail package offered by many publications (essentially an automated response to leads from your ad). Separating your mailer from others and creating a superior product will target the discriminating client. However, if you are not investing the time and the money in sending out your own response, take advantage of the opportunity and send out theirs! Something is better than nothing.

Furthermore, as recommended by Christina Smith, publisher of Orlando's *The Perfect Wedding Guide*, consider the following suggestions when placing an advertisement with a bridal publication.

1. Avoid hard-to-read or fancy fonts.
2. Avoid excessive wordiness.
3. Analyze the course of action your reader should take.
4. Give the viewer a reason to call.

Separating your mail piece from others and creating a superior product will target the discriminating client.

5. Include a contact name with the phone number. Brides like to know who they are calling. It helps put them at ease.

6. Include a phone number, website and e-mail address that jumps out at the viewer.

7. Brides are visual—use at least one photo in your ad. Don't be overzealous, and be careful to avoid clutter!

Stock Photography

Finally, take the time to produce stock photography! There are many publications that use photographs from photographers in different markets, because locals do not submit their own work. Stock photography is considered *free* advertising—take advantage of the opportunity.

Many photographers say, "I don't know what they are looking for!" This is their excuse for not taking the time to contribute. This obstacle can be overcome by investing a little profitable time and research in the endeavor. Review a copy of a past publication, page by page, to gather ideas. Typically, publications require stock photos for: bachelor/bachelorette parties, balloon designs, bridal attire, bridal beauty, bridal gifts/registry, wedding cakes, invitations and accessories, flowers, reception sites, and entertainment/dance.

Submitting these types of photos on a continuous basis will get you your free advertising and recognition in the community. It can also make the wedding day more interesting, because you begin to photograph from a different, more broadly targeted perspective.

(Below) The Perfect Wedding Guide (three examples shown below) is just one company that uses stock photography in their advertisements. (Photos by Jeff Hawkins, Ad design courtesy of The Perfect Wedding Guide)

(Following two pages) While shooting each wedding, look for possible images to shoot and sell as stock photos. Vendors of all wedding industry services (from reception halls, to bakeries to dress shops) constantly need updated images for their own advertising.

INTERVIEWING WITH INTEGRITY

ONCE THE LEAD HAS BEEN GENERATED, efficient marketing is required to ensure the largest financial gain. Remember, leads equal profit. Poor lead tracking and ineffective lead follow-up can be very hazardous and costly to your business.

Important Qualities

Always bear in mind the top five qualities brides are searching for when hiring their bridal vendors.

Appearance—As the old cliché goes, "You never get a second chance to make a positive first impression." Your bride will begin to judge you based upon her impressions in the first few seconds of your meeting. She will evaluate the appearance of your literature, the appearance of your studio, the appearance of your bridal show exhibit and, lastly, your personal appearance. You will not appeal to a million-dollar bridal market if you are dressed in jeans and a t-shirt—even if you *have* had a long week! Always remember that your appearance is a form of nonverbal communication. Before disregarding the importance of this, ask yourself these true or false questions:

> **T/F** As a business owner, how you dress does not reflect the clients you maintain.

> **T/F** You should never consider with whom you are meeting when you are planning how to dress.

Your bride will begin to judge you based upon her impressions in the first few seconds of your meeting.

T/F The time of day should have no bearing on what you wear.

T/F There's no real need to update your hair and make-up style on a regular basis.

T/F Because you are an artist, you should always follow fashion trends.

T/F When selecting casual attire for work you should wear whatever is comfortable or whatever you do on your days off, because you are self-employed.

T/F Long hair or excessive ungroomed facial hair is well accepted and respected as your artistic preference and will not deter a bride's mother from contracting your services.

T/F How you print your interview literature is up to you. It is the quality of your photographs that count, not your paperwork.

T/F The more images you display the better, regardless of the space size, you want the client to see as much work as possible.

T/F If you have been in business for a long time and are not computer or technically advanced, your clients will understand and not expect that from you.

If you replied *TRUE* to any of the above questions, your image may be negatively impacting your business. Brides will formulate many different opinions within the first few seconds of meeting you. You are not only selling the quality and the appearance of your images, you are also selling *you*!

Qualifications—Once a bride feels assured that you are a professional and are not going to scare away her guests, she will begin considering your photographic qualifications. Keep in mind that, to a photographer, "qualifications" are usually technical skills. However, to the average bride who has never been married and has very little knowledge of photography, "qualifications" are based upon the photographer's appearance and a sense that your work reflects the style she is searching for. Most brides will use vendor referrals as a way to measure a photographer's qualifications. The assumption is that if you are being referred by someone they trust and respect, you must be qualified. To ensure you are receiving good referrals, you may wish to review the networking section on page 18.

Communication Skills—*Speaking* is worthless, *communicating* is priceless. There are two forms of communication—verbal and nonverbal.

Most brides will use vendor referrals as a way to measure a photographer's qualifications.

Verbal communication can be defined as what an individual has to say and how they verbally promote listening with words. _Nonverbal communication_ is speaking and listening with your body language. Either way, when working with your clients, begin by listening. Receive the information your prospective client is sharing before you begin to send your own messages.

In order for an interview to be effective, you must properly send and receive messages. To make this experience most effective, you should consider utilizing the following techniques:

Listening

Be Quiet—Listen without thinking about how you wish to respond. Allow a few seconds to pass before you respond.

Maintain Eye Contact—Eye contact is a way of acknowledging what someone is saying. It's a documented fact that if you are not looking, you may not hear everything the speaker is saying.

Body Language—Display openness. Do not slouch in your chair. It conveys a carefree attitude. However, do not cross your arms and shut yourself off, either.

Posture—Sit up straight and be attentive.

Do Not Interrupt—Do not add your stories or experiences.

Send Vocal Pauses—Give the couple vocalized feedback by saying things like "Oh," "Hmm," "Okay," "Wow," and nodding your head.

Restate What The Speaker Has Said to You—This lets the clients know that you were listening and gives them feedback.

Don't Fake It—Don't pretend to listen, it will show!

Determine What the Client is Saying—Hear and understand their complaints and requests.

Clients' Body Language—Observe it as they speak.

Speaking

Don't Judge—Avoid judging, blaming, or criticizing—especially in regard to another vendor.

Ask Questions—Ask open-ended questions, such as: _"Do you see the value of hiring a photographer with backup equipment and an_

Receive the information your prospective client is sharing before you begin to send your own information.

assistant?" or *"Is there any reason why we couldn't get your paper-work started today?"* or *"What is most important to you, in regards to the photographer you select?"* or *"Could you get excited about hiring a photographer who is dependable and high in quality, and having one less stressful thing to worry about on the day of your wedding?"*

Tone of Voice—Watch your nonverbal message. Watch your tone of voice when you respond to some of the following questions/comments: *"I have to discuss this with my parents."* or *"What kind of cameras do you use?"* or perhaps *"I have a budget, what are your prices?"* Often *how* you say something says a lot more than the words you are saying—imagine your spouse saying, "No, I am not mad!"

Be Prepared for Objections—Be prepared to overcome clients' possible objections. For example, if you know that money is an obstacle, be prepared to ask them: *"How much are you spending on catering?"* or *"What is the percentage you have set aside for your photography?"* or *"How important is your photography to you?"*

The skills you develop for interviewing should also be used when shooting. Learning to communicate better will be an asset whenever you are working with your clients.

❖ Be a S.T.A.R.

It is imperative to realize that people are different. Each individual has a different dominant personality type. By discovering what personality traits are dominant in the client and tailoring your approach and interview style to appeal to them, you can be a "S.T.A.R." Consider the following four personality types:

Supportive Personality—The supportive personality wants to keep harmony, peace, and steadiness. They are easygoing and they like to plan ahead. They make great moms and teachers. **Type of Interview**—For this interview, you will want to talk slower, be easygoing, and seem more relaxed. These clients will not make a decision until talking it over with their mother and finance. They will typically book you if others support their decision.

Task-Oriented Personality—This personality is detail-oriented, conscientious; they are perfectionists and make great accountants. **Type of Interview**—Present all the *facts*. The client will need to review them and make a logical decision. They will probably shop around and take the literature home to compare the products and prices. They will only book you if it appears to be a *logical* decision.

Assertive Personality—These are dominating, goal-oriented, cut-to-the-chase, get-to-the-point, handle-it people. They make great managers and directors. They are probably in some type of leadership position. **Type of Interview**—Don't be offended by the client's directness. Just ask them, "What is important to you in regard to your wedding photography needs?" Wait for their answer, and then reply with facts! If you give them too much information, they will get bored and stop listening. If you offer what they are looking for, they will fill out the contract and pay a deposit that night. They do not waste time in their decision-making process.

Recognition-Oriented Personality—This person is a communicator and an influencer. They like prizes, recognition, friends, and fun! **Type of Interview**—For this interview, let the client talk. Praise them for the work they have done in regards to planning their wedding. Listen to all the details regarding their big day. They have probably been planning this wedding for a lifetime, so make them feel special. If you make them feel important and bond with them as a friend, they will put a deposit down that day.

Dependability—Dependability is the fourth qualification a bridal couple requires when selecting their photographer. You can overcome this hurdle by offering referrals from past bridal couples or by providing recommendations from other wedding vendors within the community. Nevertheless, the main task that one can complete to ensure dependability is to simply strive for consistency in dealing with others.

Critical Thinking Skills—Solid critical thinking skills are a valuable commodity to anyone in the wedding industry. Critical thinking skills may be judged by the ability to spot assumptions, weigh evidence, separate fact from opinion and see things from more than one perspective. Critical thinking skills are required when it comes to working with equipment—especially for the wedding photojournalism style. Critical thinking skills are extremely valuable the day of the wedding. Good critical thinking skills will assist in creating good photo relations and public relations on the wedding day. They are also helpful for building mutually profitable relationships with other wedding vendors.

> Good critical thinking skills will assist in creating good photo relations and public relations on the wedding day.

❖ When Problems Arise

In running a successful business, you encounter clients, customers, employees, and business associates every day. In order to avoid conflict, apply critical thinking techniques to your daily business practices. Unfortunately, times will arise when conflict will occur. For instance, a videographer may interfere with your images on the wedding day. A mother might disagree with your business practices, a client could misinterpret one of your policies, or an employee may create havoc in the workplace. When these problems occur, consider implementing the following practices:

1. Step back and breathe. Don't react with anxiety.

2. Speak up and explain your perspective. Do this in a nonconfrontational manner.

3. Commit to the relationship. You have developed a relationship with the bride. Commit to not interfering in her day! Do your best to solve the problem without getting the bride involved.

4. Refer back to common ground. If dealing with a videographer, remember you are both there for the same reason.

5. Hear their complaint. Listen to their point of view as well.

6. Don't get emotional! Realize cultural (and other) differences may affect the situation.

7. Apologize if needed. This often makes a big difference and relieves stress.

8. If the problem is not solved that day, write a letter. This will help portray your concerns and feelings in a more rational, logical fashion than in the heat of the moment.

9. Agree to disagree. Do what it takes to make the best of the situation and work around obstacles.

Interviewing your clients begins with a tour of your gallery.

✦ The Interviewing Process

Interviewing your clients requires adept product knowledge, effective communication skills, advanced critical thinking skills, and excellent interpersonal skills. You should implement the previously described communication techniques throughout the interview process described below. When displaying your work and style, strive to create a benefit so valuable the client cannot afford to go someplace else. Make the clients fall in love with your work, the products you offer, and your company as a whole.

Step 1: The Tour—You begin the process of selling during the tour of your gallery, regardless of whether you possess a residential or commercial gallery. Begin by displaying contemporary styles in black & white as well as color—photojournalistic or fine art images, for instance. Make them fall in love with your images as well as your custom frames. Show them a wall folio of the intimate details of the day—the back of the dress, the jewelry, the shoes. Show an image with a little hand tinting or digital effects via Adobe® Photoshop®—just to let them know these options are available. You would hate a bride to go elsewhere, just because they appreciate a look that you

don't (even if the technique may be slightly passé). As you continue your little jaunt, begin to show them the "mom shots." These are the traditional posed images that everyone needs to do, but usually hates doing. An image of the bride and groom alone, or a custom-framed 30"x40" of the bridal party, will ease conservative minds and show them that you can provide both cutting-edge and classic styles.

Next, showcase some shots from an engagement portrait session. Grooms usually prefer a session held on location, as it makes them feel more relaxed and at ease. At this time, ask them how they met and how he proposed. They will probably laugh. Nevertheless, once they feel assured your question was genuine and you really want to hear the answer, they will gladly open up and begin to tell you about one of the most important moments in their life.

This is where your bond begins and your nonverbal listening skills are most important! Hear what she/he is saying. Hear what was magical or important to them and begin to paint a picture with them in it, as you are visualizing yourself conducting their engagement session. Continue painting that picture by displaying a relatively small image of a baby portrait or mother with child. Explain to them that you want to create a relationship

During your tour, you should show a full range of work, from engagement portraits (below) to formals of the wedding party (opposite).

with them that lasts a lifetime—not just for their wedding day. Consider offering all of your brides a free baby portrait of their firstborn child—then laugh and remind them that there is *no expiration date*!

Step 2: The Consultation—At this time, take your seat in a nice cozy area. Select warm earth-tone colors when decorating your consultation area. This will lower the couple's defense mechanisms and make them feel cozy and comfortable. Set the mood by playing easy instrumental music, have tissues (in case your images move them to tears) and expensive wrapped candy available for them. You have initiated a bond and are warming up your client. You should have noticed their responses to the different images, and determined what appealed to them the most. You are beginning to identify the product that appeals to them and the type of people they are.

Now, give them a few minutes alone. You have talked enough for a while! Let them warm up to the studio and look at a few albums. Show them different album styles. For example, display a parent album with traditional images to appeal to a traditional mom. Also, select a more

After the tour, sit down with the clients in a cozy, comfortable area for the consultation.

contemporary album to showcase photojournalistic images. You may also want to highlight another album to demonstrate a complete storytelling book. The goal is to select a variety of styles, some that are tailored specifically to appeal to the client, and some that will appeal to a wider audience. Be careful not to overwhelm the client with too many albums, though. When a bridal couple spends an excessive amount of time reviewing albums, they stop looking at your photography and start looking at everyone else's work—cakes, shoes, dresses, centerpieces, etc. Your goal is to spend the time bonding with them and selling them on the products and services *you* have to offer.

Showing clients the different album styles available is an important step in the consultation. (Photo courtesy of Art Leather)

Step 3: Consultation Questionnaire—At this particular point, have the couple complete the wedding consultation sheet. See the illustration provided on page 51 for details of what you may wish to include on your sheet. Most importantly, include the following: the couple's wedding date, their e-mail addresses, ceremony and reception locations, other photographers visited, and other vendors contracted for their special day.

Begin the interview by discussing the items on their questionnaire. You should already know how they met and how he proposed. Now discover more about their big day. Ask what feel or theme they are planning. If they seem clueless, they are probably just being shy and want to know if your question is sincere. Practice your listening techniques. Visualize what they are imagining. Your objective is to learn whether they are planning a simple and elegant gala, a fairy-tale event, or the party of the century. This should tell you about the products they need and their personality types.

For example, a *supportive personality* will be very concerned with everyone attending. She will probably not come to the interview alone, and the significant other or parent will be very involved in the planning process. However, the *task-oriented personality* will have purchased wedding planners and will most likely tell you every detail they have visualized and coordinated. They will also want you to give them a ton of information. Listen carefully, and they will tell you what they want. The *assertive personality* usually wants something simpler and not a lot of fluff. Key in to this—you will want to show simple album styles and get straight to the point. Finally, the *recognition-oriented personality* is most likely to want a true fairy-tale wedding. She has probably dreamed of being the center of attention on this day since she was a little girl and can paint a perfect picture of what her day will be like. Allowing each personality to describe the details of their day will assist in the interviewing process, and begin to build a bond of trust between you and your client.

Your relationship with the client begins with the first interview. The friendly and professional tone you set will help ensure a relaxed and productive experience on the wedding day.

Before selling your prices, products, and services, make a note of the vendors they have hired and the other photographers they have met with already. This will tell you who your competition is and what vendors you may be working with. Be familiar with the vendors and photographers in your area. Knowing the products and prices they offer their clients will give you the upper hand in an interview.

Step 4: The Interviewing Packet—Like us, you may find it effective to include two separate sections in the interviewing packet. First, notate your prices separately. We suggest utilizing pricing levels rather than set packages. Unlike a set package where the number of prints in each size is set, a pricing level setup establishes a budget for your client, without requiring that a specific number of images be purchased. Begin by walking the client through their options. Discuss the types of album styles and the prices for the covers. Next, review the image prices, for example a 5"x5" is $18.00, whereas an 8"x10" image is $30.00. Explain to them that it is impossible to guess how many images they will have until after they see their selection.

The interviewing packet contains important information about print sizes, pricing, albums, etc.

Also, explain to them that the characteristics of each image will determine whether it would be best as a 4"x5" or an 8"x10". Our goal is to establish a *storybook*, not a scrapbook!

After you showcase your products, you should be able to identify what appeals to your client and what type of products they are most interested in purchasing. At this time, create a pricing level that suits their needs. Your pricing levels should reflect your time, film, processing, and album design time. Include a bridal album cover, parent albums, etc. The precise types of products the client will want are established based upon the likes and trends in your marketing demographic. A portion of the total pricing level should be set aside as a product credit. A product credit can be defined as funds set aside on "layaway" to be used to fill their albums. This is the money that will purchase the 8"x10"s, 5"x7"s, etc. Explain to the client that if they do not utilize their entire product credit it will be refunded, and if they exceed their credit, there will be a balance due. This will ease their minds somewhat in regards to finances and make them feel more comfortable about increasing their photography budget.

Once you have reviewed the available pricing levels, recommend the level that would be most appropriate for the couple based upon the needs they have specified. Inform them that there is a $500 retainer due to secure the photographer's services and lock in the current prices. Use the word "retainer" to indicate that this money is nonrefundable. Finally, let the couple know that the $500 retainer is subtracted from the balance due, and that the remaining balance is due the week before the wedding. At that time, you will schedule an appointment to review the allotted times, the participants, and any significant instructions.

Your pricing levels should reflect your time, film, processing, and album design time.

▨ Consider a Salesperson

It may be easier for a person other than the photographer to do the selling, because it seems more appropriate for them to brag about the photographer's work. As a spouse, employee, or significant other, it seems natural to say "Don't delay! He is awesome and the date won't be available long! I strongly recommend booking today—this way you will have one less thing to worry about!"

The next few pages contain sample forms from our interview packet. These can be easily adapted to meet your own needs. On page 60 (following the forms), we'll turn to the final and most important step in the interviewing process—the close.

YOURTOWN PHOTOGRAPHY

www.YourtownPhotography.com

Wedding Consultation

Your Name: _____ Spouse-to-be: _____

Occupation: _____ Occupation: _____

Address: _____ City: _____ State: ___ Zip: _____

Home Phone: _____ Work Phone: _____

E-Mail: _____ Pager/Cellular: _____

Bride's Parents: _____ Groom's Parents: _____

Address: _____ Address: _____

City : _____ State: ___ Zip: _____ City : _____ State: ___ Zip: _____

Phone: _____ Phone: _____

Wedding Location/Times Wedding Date: _____

Where will you be getting ready? _____ Time: _____

Ceremony Location: _____ Time: _____

Reception Location: _____ Time: _____ Until: _____

How many attendants? Bridesmaids: _____ Groomsmen: _____ Ring Bearer: _____ Flower Girl: _____

How many guests are you expecting to attend? _____ Out-of-town Guests: _____

What Vendors Have You Contacted?

DJ: _____ Cake: _____ Video: _____

Minister: _____ Flowers: _____ Dress: _____

Caterer: _____ Limo: _____

Have you met with any other photographers? If so, whom? _____

Notes: _____

On – Line Ordering Now Available

Special Introductory Rate only $99.00

Now available to help make ordering easier
for your friends and family members,
you can display a selection of your wedding day images
on-line! Display up to 100 of your special images
for only $99.00. Add your on-line package to your pricing level
today to be eligible for the introductory special!
Standard Price $150.00

Images will be selected at the discretion of Jeff Hawkins Photography and will be displayed
for a minimum of 60 days! A secret code will be issued for Privacy Assurance

The Wedding of:_____ Wedding Date:_____
Name:_____
Address:_____
Home Phone:_____ Work Phone:_____
Email Address:_____
Credit Card #_____
Exp date:_____ Visa MC Discover Amex Check

Call 407-834-8023 for additional information….also ask about adding your Engagement Portraits on-line

▦ Service Levels

Our service is provided at seven different levels. In the interview packet, the specifications for each level are provided on separate pages. Here, the material is presented in a slightly more condensed form in order to conserve space.

Premier Level

The ultimate level in wedding photography—when you want only the finest for your special day! The premier level includes:

Total unlimited coverage

- Engagement Love Portrait session with one custom framed 16"x20"
- Formal bridal session with one custom-framed 20"x24"
- One custom framed 16"x20" black & white print
- Signature frame, including one 11"x14" print, carrying case, and imprinting
- Two hours of rehearsal dinner coverage
- One medium image box with 18 matted prints
- Two custom Art Leather Black Onyx albums complete with images—OR—two 10"x10" White Glove albums complete with images
- Two custom Art Leather Black Onyx 30-page family albums
- Personal bridal assistant for ceremony and reception
- On-line images
- Five preview videos

Total Investment: $00,000

Level 1

Incredible coverage for clients who understand the importance of documenting their wedding day with complete coverage and a distinguished style. This premier coverage includes:

- Up to two hours of rehearsal dinner coverage
- Two Art Leather, Top Grain leather album covers—OR—a 10"x10" White Glove book with cover and assembly
- White Glove book jacket
- Two 5"x7" family albums, containing 24–5"x7" images in each
- One custom-framed wall folio
- One custom signature frame
- Personal bridal assistant for ceremony and reception
- Engagement session
- Formal bridal session
- Three preview videos
- On-line ordering

Total Investment: $00,000 ($0,000 product credit for album purchase)

Level 2

Unlimited coverage for discerning clients who demand excellence. Sensitive and stunning wedding photojournalism, masterfully and elegantly presented for posterity. This elite level includes:

- One 10"x10" White Glove book with cover and assembly
- Two 5"x7" family albums containing 20–5"x7" images in each
- Personal bridal assistant for ceremony and reception
- Engagement session
- Formal bridal session
- Three preview videos

Total Investment: $0,000 ($0,000 product credit for album purchase)

Level 3

This new level includes our most sought-after product line, the White Glove First Edition book:

No Time Limits, No Image Limits
- One custom Black Onyx album cover
- One 10"x10" White Glove book with cover and assembly
- One book jacket (includes cover and one image)
- Personal bridal assistant for ceremony only
- Engagement session
- Formal bridal session
- Three preview videos

Total Investment: $0,000 ($0,000 product credit for album purchase)

Level 4

No Time Limits, No Image Limits
- One custom Black Onyx album cover
- One small image box with 12 images—or—one parent album with 16–5"x7" images
- Unlimited black & white and color images
- Personal bridal assistant for ceremony only
- Engagement session
- Three preview videos

Total Investment: $0,000 ($0,000 product credit for album purchase)

Level 5

Up to five hours of coverage. Extra hours $000.00

- One custom bridal album cover
- Unlimited color film
- Black & white film $40 per roll
- Three preview videos

Total Investment: $0,000 ($0,000 product credit for album purchase)

Level 6

Up to four hours of coverage. Extra hours $000.00

- Preview video

Total Investment: $0,000 (all products à la carte)

Retainer

A nonrefundable retainer of $000 is required to reserve your wedding date. This is on a first come, first serve basis, as we book our dates far in advance. This retainer will be deducted from your (total) pricing level. The balance of the level shall be due one week before the wedding.

Print Collection

Custom Wall Portraits	Album/Reprint Sizes	Black & White Sizes
30x40—$000	11x14—$000	11x14—$000
30x30—$000	10x10—$00	10x10—$00
20x24—$000	8x10—$00	8x10—$00
20x20—$000	5x7—$00	5x7—$00
16x20—$000	5x5—$00	5x5—$00
16x16—$000	4x5—$00	4x5—$00
11x14—$000	8 wallets—$00	

Wall portraits are custom-framed with double matting, acrylic and mounting hardware. For canvas, add $000. Other sizes available. Prices are subject to change without notice.

Large Futura	Aristohyde $000	Top grain leather $000
Medium Futura	Aristohyde $000	Top grain leather $000
Futura Galaxie	Aristohyde $000	Top grain leather $000

Album pages—$00 (Includes insert and two designer mats. Does not include prints.)

Our Designer Collection

Black Onyx Album

This stylish album steps away from tradition. It offers an artistic touch to your images.
Cover titles can be printed in black, silver or gold.

Large album cover—$000 Pages—$00 each (includes insert and two mats)

The Image Box

The classy way to have those images stand apart from the rest.

Large cover includes 18 mats—$000
Medium cover includes 18 mats—000
Small cover includes 10 mats—$000

Image cutout on cover—$00 Photographs additional.

Designer Signature Frame

Your beautifully framed portrait greets your guests as they arrive, allowing them to sign in with style. The complete kit includes the designer frame, signature mat (customized with your name and wedding date), one custom 11"x14" portrait, gold/silver pen, and a custom gift box for easy transportation.

$000 (plus shipping)

Personal Bridal Assistant

Your special day will be a stressful one. With your own personal bridal assistant, you can be assured that your stress will be relieved. From breath mints, to touching up your makeup, she will take care of the little things that really make a difference. Services start at:

$000 for ceremony coverage
$000 for ceremony and reception coverage

Gift Certificates

Have friends and family assist you with your purchases, adding to your credit! These wonderful certificates are available in $25.00 increments. Let your friends and family know you are registered with

Yourtown Photography

Keepsake Futura Folios

This popular item is a perfect gift for the wedding party—a great way for everyone to remember your special wedding day!

Folio complete with two 4"x5" photographs, regularly $00
If purchased before the wedding day, only $00

Wall Folio Collection

This wonderful addition makes a wonderful addition for the parent or the bridal couple who is looking to make a unique yet lasting impression. This 16"x24" beveled acid-free double-mat frame elegantly displays your favorite 8"x10", coupled with two 5"x7" images. To make a picture perfect match with your décor, you may select from classic gold, silver, traditional cherry, or contemporary black and white frames. *$000*

—Also available are the Gift Essentials, Gift Sensations
and Desk Collection products.
Prices vary based on image size and frame selection.
Please see your Gift Collection catalog.—

White Glove
First Edition Books

It is with great pleasure that we introduce the White Glove books. These books are unlike any other conventional photograph album you have ever seen. The White Glove books do more than showcase weddings. In fact, they can be used to safeguard family photographs, or as baby and children's albums.

There are six cover designs and six effects that may be applied to images. Multiple effects can be combined as well.

You can also choose from 75 verses, or supply your own. See <www.wgbooks.com>.

Covers

Step 1
Purchase book. Includes one cover and assembly.

10"x10"—$000
5"x5"—$000

Step 2
Add images.

Each image—$000

BONUS! Each additional (duplicate) book, including images, ONLY:
10"x10"—$000
5"x5"—$000

White Glove First Edition books are created with permanence in mind.
All materials are archival and acid free.
The decorative cover materials are made of fine imported
papers and book cloth.

On-Line Ordering

Now available to help make ordering easier for your friends and family members, you can display a selection of your images on-line! Display up to 100 images from your special day on our website. Image selection will be determined at the discretion of Yourtown Photography. You will also receive a personal, private code to allow private access to just your selected visitors. Images will be displayed for sixty days.

Special Introductory Price, Only $000
Standard Fee $000

Travel Fees

A fee of $00 per hour plus expenses is required for travel more than one hour from the studio location. Client is responsible for overnight accommodations, if necessary.

Yourtown Photography
P.O. Box 1
Yourtown, FL 00000-0000

Studio: (555)555-0000
Fax: (555)555-0001
Voice Mail: (555)555-0002
Toll Free: (800)555-0003

Website: <www.YourtownPhotography.com>

E-mail: John@YourtownPhotography.com

❖ Review the Process

1. Make the connection between "need" and "benefit." The most effective way to book a client is to personalize the reasons they would want to use your services.

2. Hear their words and their body language.

3. Understand and respond to the different personality types. Learn to be a S.T.A.R.

4. Overcome objections. You must ready for those prospective customers who are reluctant about scheduling a visit to your gallery or about placing a deposit and filling out the paperwork. This is not difficult if you are able to replace a negative thought with a positive one. The formula for handling concerns is as follows:

 a. Relax and be positive
 b. Repeat the concern
 c. Respond with solutions that address the concern

Step 5: The Close—The most important step in closing the sale is asking for it, and asking for it with confidence. First, ask if they have any other questions. If they do not, say "Great, is there any reason why we couldn't get your paperwork started and give you one less thing to worry about?" If they say no, shut up—say no more. Pull out the paperwork, place it in front of them, and say, "Please begin filling out the top half of this form. I will walk you through the rest."

If they are not ready to complete the paperwork, hear the reason why. Sometimes a potential client may be interested in using your services but is concerned about the finances or may feel compelled to discuss it with a family member or friend. Their response may *seem* negative, but is really just a request for more information. Clients need to feel that you understand their concerns and are responding honestly. If you have been listening to their words, watching their body language, and they appear to sincerely *like* your services, their main objection is probably price. How you respond to the objection will determine how much effort they will put into overcoming the obstacle and using your services. As always, keep the conversation relaxed and positive. Repeat the concern, letting them know that you are paying attention to their needs. Provide them with any information you have that addresses that concern—again, keeping the discussion positive at all times.

Clients need to feel that you understand their concerns and are responding honestly.

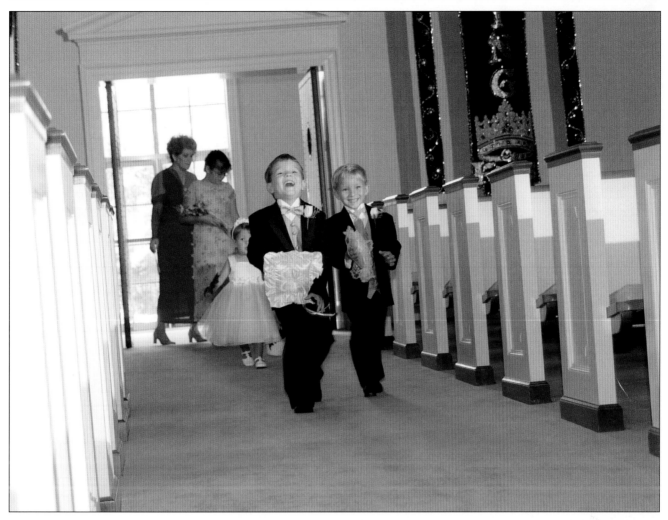

◈ Customer Service Savvy

Once you have met with a client or scheduled an appointment it is very important to follow up with finesse.

Once you have met with a client or scheduled an appointment it is very important to follow up with finesse. After the initial lead call, schedule a visit to your studio and follow up by sending an "appointment card" with directions to your facility. Secondly, after each interview, respond by mailing a "thank you for considering" postcard (examples on page 32). Lastly, after each client books his or her services with you, send a "don't forget" postcard. A wedding worksheet (which requests the name of the vendors the couple selected as well as a detailed itinerary for their day) should also be sent to each couple along with a personal bridal assistant flyer. Following up with your customers will create a stronger relationship and ease their anxiety about the big day. Additional follow-up programs should be implemented after their wedding day, as well. This will develop a relationship with the family that you should aspire to develop for a lifetime.

On the following pages you'll find a sample contract, as well as samples of other forms and mailers you can use to keep in touch with your clients before their weddings.

YOURTOWN PHOTOGRAPHY
www.YourtownPhotography.com

Wedding Photography Contract

Engagement Sitting	Formal Sitting	Date of Wedding

Bride: _____ **Groom:** _____

 Primary Address: _____

 City: _____ State: _____ Zip: _____

 Home Phone: _____ Work Phone: _____

 Pager/Cellular: _____ E-Mail: _____

Occupation: _____ DOB: _____ Occupation: _____ DOB: _____

Bride's Parents	Groom's Parents

Name: _____ Name: _____

Address: _____ Address: _____

City: _____ State: _____ Zip: _____ City: _____ State: _____ Zip: _____

Phone: _____ Phone: _____

E-Mail: _____ E-Mail: _____

Pre-Ceremony Photo Location: _____ Start Time: _____

 Address: _____

Ceremony Location: _____ Start Time: _____ End Time: _____

 Address: _____

Reception Location: _____ Start Time: _____ End Time: _____

 Address: _____

Payment Required:

_____ Total Charges

_____ Personal Bridal Assistant

_____ Additions

_____ Sales Tax

_____ Total Due

_____ NON-Refundable Deposit (Date Paid_____)

_____ Balance Due (Date Paid_____)

I agree to pay the required fees above.

Signature Date

Description:

Yourtown Photography
555 Main St.
Yourtown, FL 55555

AGREEMENT FOR WEDDING PHOTOGRAPHY COVERAGE

This agreement, entered into on _____ is between Yourtown Photography, in the State of Florida and doing business as John Doe Photography, and the undersigned (hereinafter referred to as "Client") relating to the wedding of that will take place on_____.

SERVICE COVERAGE: The parties agree that Yourtown Photography will furnish the services of a professional photographer. John Doe and a trained assistant (if needed) will begin photographic coverage at_____until the conclusion of the event. The fee for professional services (exclusive of products) for reservation and event coverage is $_____. It is agreed that John Doe will be the sole still photographer employed for the wedding day. Simultaneous photographic coverage by another contracted photographer shall release John Doe from this agreement and the professional fee will be retained. In addition, we request that guests and professional videographers NOT take pictures of our set up/posed shots, as doing so may delay the process and effect or ruin the outcome of your photographs. Due to the fact that weddings are uncontrolled events, we cannot guarantee any specific photograph or pose. We will, however, attempt to honor special requests. Likewise, Personal Bridal Assistant services and responsibilities will be assigned as deemed necessary and at the sole discretion of Yourtown Photography.

PAYMENT POLICY and EXPENSES: A fee of $_____ is retained herewith to reserve event coverage for the service coverage specified above. This fee is nonrefundable, but may reapplied (subject to availability) if the event is rescheduled. A final payment of $_____ will be paid by the Client no later than one week prior to the event, plus reimbursement of applicable airfare, hotel and transfer expenses incurred by John Doe in performing the photographic duties expressed herein. This $_____ credit is applied toward album purchase. Should the purchase price be less than the amount of the credit, that amount will be refunded. If the final purchase price exceeds the credit, payment of half of the balance will be required to begin construction of the album(s), with the final balance to be paid on delivery of the album. The selection of the bridal album photographs must begin within two weeks of viewing the video or the album design layout. *With respect to Product Credits: Credits and applicable products not used/ordered within 6 months of receiving the video will be forfeited. Contractual modifications will be subject to a service charge.*

PRODUCT PRICING: Pricing is defined on the attached price list. All prices quoted for professional services, photographs and albums are valid for a period of two months following the date of the wedding. Orders placed after two months following the wedding are billed at the studio's currently published prices, which may be greater.

LIMITATION of LIABILITY: While every reasonable effort will be made to produce and deliver outstanding photographs of the wedding events, Yourtown Photography's entire liability to the Client for claim, loss or injury arising from John Doe's performance is limited to a refund to Client of the amount paid for services. Because this is an uncontrolled event, Yourtown Photography cannot guarantee delivery of any specifically requested image(s). As mentioned above, if our services are canceled for any reason, the deposit paid to reserve the date is nonrefundable. In the unlikely event of personal illness or other circumstances beyond the control of John Doe, a substitute photographer of high qualifications, subject to the acceptance by Client prior to the event, may be dispatched by John Doe to fulfill the obligations of photography herein contracted. In such case that Client declines John Doe's sending of a substitute photographer, Client may elect instead to terminate this agreement and receive a full refund of all deposits paid to Yourtown Photography.

Signature_____

In the event there is a dispute under this contract, the parties agree that the loser will pay the winner reasonable attorneys' fees. The venue shall reside in Seminole County, Florida.

REVIEW and SELECTION: Images photographed on the day of the wedding will be digitally captured and recorded on video tape. The tape can also be used by relatives to make their print selections. You will be able to make additional copies of the tape and distribute them accordingly. Federal Copyright Laws protect these images. (See below)

ALBUM ORDERS: Using special design techniques, Yourtown Photography will advise in the layout of the album(s), however, all choices by the Client will prevail. Album orders will include choice of photographs selected (with special instruction, if any) and these are made following inspection of the captured images. To begin construction of the album(s) a deposit of half of the remaining balance is required. The balance will be due upon pick-up. Orders placed after 2 months will be priced at the studio's currently published prices, which may be greater. Following the notification of completion of order, unpaid balances will be subject to a 1.5% monthly service charge. We are not responsible for albums left unclaimed after 30 days. Delivery of John Doe's hand-assembled album(s) ordinarily occurs within 9–12 weeks after the receipt of the order. This time may vary based upon the size of the album(s).

FINANCING OPTION: Client may elect to finance the final payment of the album balance. Other options can be arranged as well.

ORDERING REPRINTS: If we are to mail orders, appropriate shipping/handling and insurance fees will be charged.

FEDERAL COPYRIGHT LAWS: Yourtown Photography owns all negatives, and original photographs and are not part of any package. We retain the rights to reproduction of any images produced in connection with this agreement. Copying or reproduction of any photograph in any form is hereby prohibited and protected under Federal Copyright Laws, and enforced to the fullest extent allowable.

PROPRIETARY IMAGES: Although Yourtown Photography owns copyrights, negatives, and unless sold separately, all original photographs taken of the wedding events, any sale, reproduction, publication or exhibition of any image produced in connection with this agreement, regardless of the ownership of the actual photographs, is prohibited without the mutual consent of the parties to this agreement. Notwithstanding the foregoing, the parties agree that Yourtown Photography may reproduce, publish or exhibit a judicious selection of such photographs as samples of photographic work to be shown to prospective clients, and for instructional or institutional purposes consistent with the highest standards of taste and judgment.

There are a total of 3 pages to this agreement. Please initial each page.

X _____Date_____ facsimile signature deemed to be original
Acceptance of contract terms by the_____party.

X_____Date_____facsimile signature deemed to be original
Authorized agent for Yourtown Photography

*Yourtown Photography • 555 Main Street • Yourtown, FL 55555 • Phone (555)555-0000•
<www.YourtownPhotography.com> • John@YourtownPhotography.com*

Wedding Worksheet

Please complete the following information and return to Yourtown Photography

The Wedding of _____

Church: _____ Contact: _____ Phone: _____
Officiant: _____ Phone: _____
Reception: _____ Contact: _____ Phone: _____

Wedding Coordinator: _____ Phone: _____
Caterer: _____ Phone: _____
Cake: _____ Phone: _____
DJ: _____ Phone: _____
Band: _____ Phone: _____
Other Entertainment: _____ Phone: _____
Videographer: _____ Phone: _____
Florist: _____ Phone: _____
Limo: _____ Phone: _____
Tux: _____ Phone: _____
Dress: _____ Phone: _____

Bride's phone number for day of event: _____
Groom's phone number for day of event: _____

When will you arrive at the church or ceremony location? _____
When will you leave the reception? _____
Are you planning a special exit? _____
Will you be leaving in special transportation? _____

Please attach an itinerary of the reception events.

Any special requests?

Designing the Perfect Love Portrait

Here at Yourtown Photography, we understand that your Love Portrait is going to be the beginning of a new adventure in your life. We want to document this special time for you and begin capturing memories that last a lifetime!

To ensure your portrait is as beautiful as can be, try to follow these suggested guidelines:

1. Schedule your portrait a minimum of 6 to 8 weeks prior to your wedding day. The sooner the better! This allows adequate time for lab processing.

2. Choose outfits that suit your personality and make you feel attractive! Make sure you create color harmony and both outfits coordinate well together. Please do not wear short shorts or skirts. This makes posing more difficult. Long, flowing dresses, jeans, or khakis make better selections.

3. Start thinking about props! This can make your photograph unique. Consider a picnic basket with wine glasses and a blanket, a straw hat, a musical instrument—even animals! We can also utilize larger objects such as: boats, sport cars, planes, or motorcycles.

4. Don't worry about the location! Once you chose your wardrobe and schedule an appointment, we will discuss location and time with you. We have access to many secret hideaways—just tell us what you envision. We can create the rest.

5. Become alert to interesting photographs. Look out for romantic postcards or magazine advertisements. We can often recreate art with you as the subject.

6. Keep in mind that many couples chose to utilize their Love Portrait to display at their reception (perhaps in our designer Signature Frame), or to include in the invitations, or to distribute framed as the perfect party favor or bridal party gifts.

7. While we are creating your Love Portrait, if you have a sister, a brother, or a best friend you would like a portrait of, bring them along. We can just as easily do two or three sittings at the same time as one. Give Mom that family portrait she has been wanting! Please discuss your ideas when scheduling your session.

8. Have fun!

Feel free to contact us at (555)555-0000,
if you have any additional questions or concerns, or to schedule your
Love Portrait!

How to Avoid the Ten Most Common Makeup Mistakes on Your Wedding Day

All eyes will be on you—make sure every inch is worthy of close-up attention!

1. DO USE PROPER SKIN CARE. Give nature a helping hand by starting a basic skin care program 2–3 months prior to your wedding. A morning and evening regimen of cleansing, freshening and moisturizing primes you face for the sheer makeup look brides love.

2. DO WEAR MAKEUP. Often, the filter the photographer uses softens your look and washes you out, creating a lower contrast. Use makeup to accentuate, enhance and define your best features. Minor imperfections may be neatly corrected by using a concealer. The important thing is to experiment before your wedding day.

3. DO USE COLOR HARMONY. To harmonize, choose makeup and clothes with a single undertone—either vibrantly cool or radiantly warm. Make sure you harmonize lip color, cheek color and nail color. The entire bridal party should apply this rule. Neutral browns photograph the best.

4. DO USE WATERPROOF MASCARA. This is one of the happiest moments of your life, and you'll undoubtedly shed a few tears! Layer brown and black mascara for longer looking lashes.

5. DO USE LIPSTICK AND LIPLINER. Select a lipstick rich in moisturizers and emollients for the ultimate in kissable lips. Line first, then use a brush to apply color. Reapply for staying power. Add a touch of gloss for shine, but avoid frosted lipstick.

6. DO USE TRANSLUCENT FACE POWDER. This sets makeup and provides a matte finish. It also helps control oil breakthrough and shine. Always select powder in the shade closest to your natural skin tone. Pressed powder is portable and can be used throughout the day.

7. DO WEAR THE CORRECT FOUNDATION SHADE. Select a shade that matches your skin at the jawline (not the back of your hand) and blend it well—especially along the hairline and jaw. This gives skin a smooth, even finish.

8. DO USE CORRECT BLUSHER APPLICATION. Blusher should provide a soft glow, and never look streaked or blotchy. For sheer and even application, use a blusher brush. Wherever you lay the brush first is where the most color will be deposited. Lightly dust face powder over blusher to tone.

9. DO WEAR A FRAGRANCE. A woman's fragrance is her personal signature—and an intimate trademark. Never overdo your aroma. Make sure you use layering techniques with your scent—applying body creams, dusting powders and colognes in a matching scent.

10. DO USE A PROFESSIONAL. Beautiful skin care and glamour isn't something you buy—it's something you learn. Learning the right beauty regimen for your skin and proper makeup application will guarantee you'll look your best.

*Feel free to contact us at (555)555-0000
if you have any questions about looking your best
for your wedding day, and in your wedding photography!*

WORKING FULL CIRCLE

T HE SECOND PART OF THE CYCLE of successful wedding photography is maintaining customer service on the wedding day. You can accomplish this task by implementing public relations in your business. When you add the very important customer service task of maintaining public relations to your photography, you arrive at the full-circle approach to customer service—photo relations! "Photo relations" (like public relations) means maintaining a positive relationship with your clients and the industry through your images and your attitude on the wedding day. Applying your critical thinking and communication skills is paramount in maintaining good photo relations with your clients. However, it is also imperative to create a proactive and unobtrusive style of work on the wedding day, and deliver images that meet or exceed all of your client's diverse needs and desires.

Photographic Style

Being proactive impacts the photographer's photographic style on the day of the wedding, demanding that he have a plan in place for unobtrusively creating beautiful images. There are many needs to balance. For example, while traditional images are vital (most parents do expect them), contemporary brides do not want to spend an excessive amount of time photographing posed images. Successful album design requires capturing the wedding day with storytelling in mind. As a photographer, you must become passionate about creating a complete album, and not just "getting by" with the required posed images.

(Opposite) One mark of a successful photographer is maintaining customer service on the wedding day, unobtrusively creating outstanding images in both classic and contemporary styles.

A complete album should show both the joy and romance of the wedding.

Photojournalism requires carefully capturing the emotions, the feelings, the intimate details. Look for the images that are not traditional. Look for interaction without interacting with them. The minute you start interacting with them, it is no longer photojournalism it becomes canned images. Become invisible. Open your eyes and start looking rather than waiting for something to happen.

You can set the scene with shots that establish the location of the actions, or the people involved.

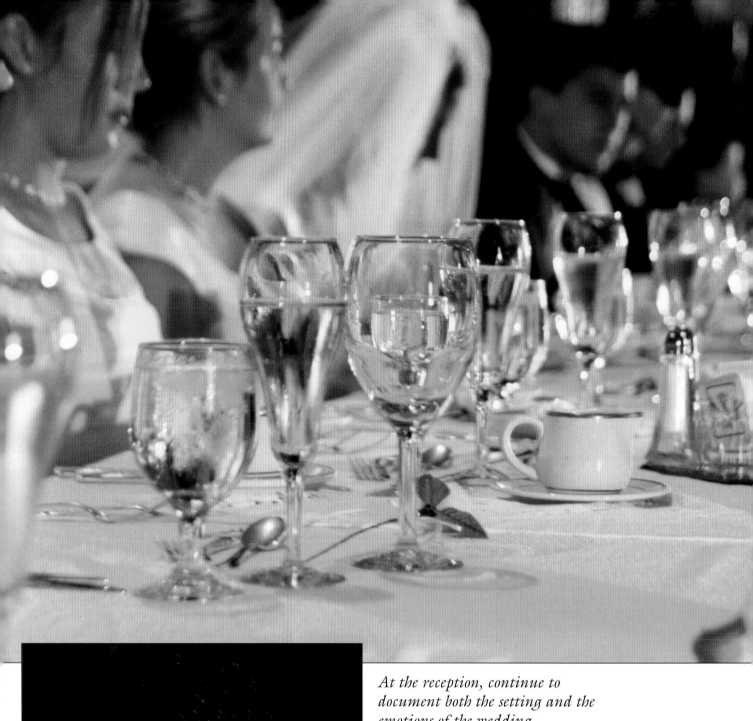

At the reception, continue to document both the setting and the emotions of the wedding.

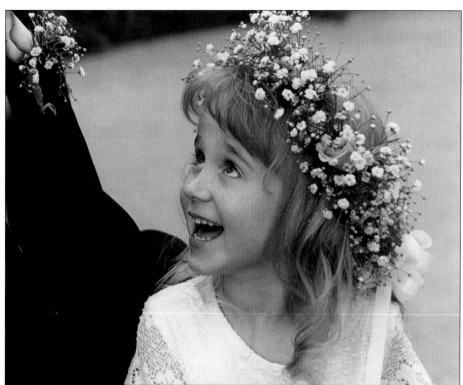

Capturing the full range of emotions of the day is crucial for creating a storytelling album.

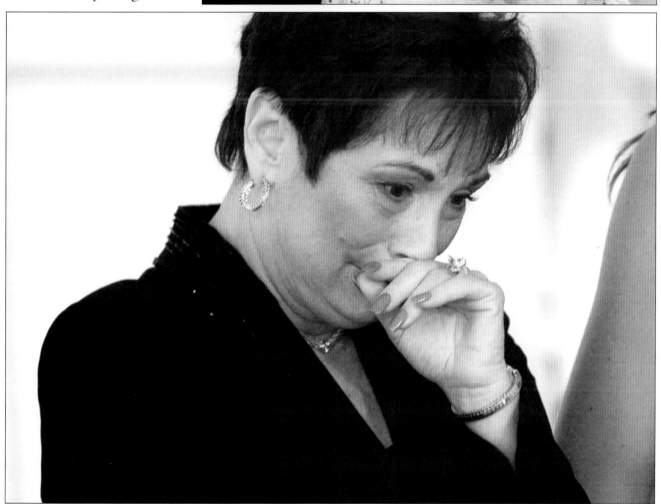

▨ Equipment

A photographer can begin creating a proactive approach by preparing for the wedding day with backup equipment. The equipment we have found most operative is as follows:

- Nikon F-5
- Nikon D-1
- 3-340meg Micro drives
- Nikon SB 28 DX flash
- Laptop computer (for downloading images)
- Nikon SB-28 flash units
- Nikon 80–200, f/2.8 lens
- Nikon 24–120, f/3.5 lens
- Nikon 28–200 lens
- Quantum Q-Flash (2) with 3-Turbo Batteries
- Radio slaves (4i)
- White Lightning Flash Units (2)
- Hasselblad 503CW
- Hasselblad 50mm
- Hasselblad 180mm
- 3-220 film backs
- Polaroid Back
- Sekonic Flash meter L-508
- Motorola Talk About 2-way radios with ear piece
- Bogen 3051 tripod with the Bogen 3265 pistol grip
- Kodak's Portra 800 (35mm and 220)

The first step in combining traditional and contemporary styles involves targeting the important elements of the wedding day. These elements include: the pre-ceremony, the ceremony, the post-ceremony, and the reception. The reception should be divided up in these different sections: first dance, toast, cake, garter, bouquet, dancing/fun, and exit. While it is important to photograph these elements in a traditional style with posed images, limiting your time in this area is crucial, since our more modern bride also appreciates the photojournalistic approach. The use of private time can assist in this area as well, and will be examined more thoroughly in the following section.

As you endeavor to work full circle on your photography relations, combining styles to create unique images for the needs of each client, you'll find yourself working faster and putting more passion and energy into your photography. Therefore, it is important to have a distinct system in place for capturing each element of the wedding day. Consider the following suggested system:

You'll find yourself working faster and putting more passion and energy into your photography.

Bride's Pre-Wedding Preparations

- House or salon
- Bridal party arriving
- Prior to getting dressed
- Emotions, nervousness, tears of joy, stress
- Key people—mom, sister, maid of honor
- Putting on the dress
- Bridal party assisting the bride
- Close-ups of expressions
- Shoes
- Jewelry
- Hair

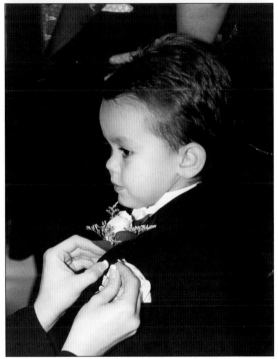

Groom's Pre-Wedding Preparation

- Groom's party arriving
- Tuxedos
- Emotions
- Pinning of boutonniere
- Ring bearer
- Marriage license
- Key people—dad, mom, best man
- Interaction with others
- Posed formals (if time permits)

Bride's Final Preparations

- Veil
- Flowers
- Dresses (backs, sides, special trim or beading)
- Posed formals (if time permits)
- Final moments
- Bride and dad interacting

Ceremony
- Grandparents and parents seating
- Crowd shots
- Entrance of the men
- Expression of the groom as he sees his bride
- Bridesmaids' entrance (try a different angle instead of shots down the aisle)
- Bride's entrance

Formals

• Group shots based upon the time allocated (if possible, allow your assistant to help gather the groupings while you watch the key people for possible photojournalistic images of expressions and emotions).

Post-Ceremony

- Candids of the family and bridal party preparing for the reception
- Bride and groom exiting the church
- Limousine
- While the DJ is getting everyone organized, scope out the reception site.
- Table seating cards
- Guest book
- Table shots
- Start thinking about possible stock photography

For additional ideas, find a mentor. Study other photographers' work to help create your own unique style. Surf the web and review photography-related websites. Create your own style and your own rules. As long as you keep the storytelling concept in mind, the images will sell. These elements will capture a plenitude of emotions, feeling, and intimacy—creating, at the same time, an abundance of good photo relations!

⊞ Ceremony/Church Etiquette

Upon arrival, observe the lighting conditions, which will vary dramatically from location to location. For easier coverage, use a high-speed film that will allow you to handhold the camera. Continue to keep an eye on the lighting conditions and be ready to adjust as appropriate.

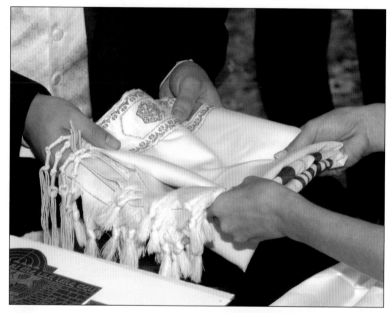

Aside from their social aspects, weddings are religious ceremonies. Photographers should always respect the sanctity of the events taking place during the ceremony.

At the ceremony, your goal is to capture the moment without getting in the way or causing a distraction.

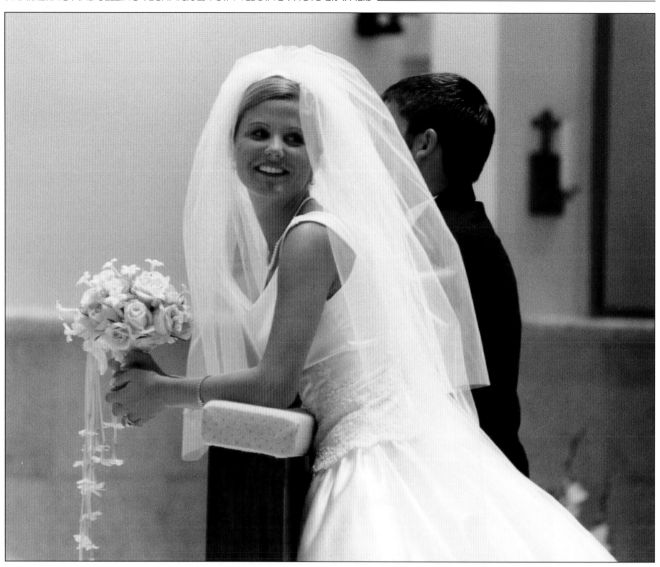

The photographer will want to capture all aspects of the ceremony—for instance: kneeling, the ring exchange, lighting of the unity candle, etc. You should also attempt to obtain an overall shot of the area and the seated guests, if possible. Most churches restrict movement and the use of flash during the ceremony, so keep movement to a minimum and do not be distracting to the minister or to the guests. The use of a fast lens and high-speed film will allow you to cover the ceremony unobtrusively and keep the story line flowing smoothly. You will also demonstrate your respect for the sanctity of the ceremony, while still capturing images that will help the couple to remember it.

Prior to the ceremony, you may wish to suggest that the bride and groom face each other or the audience when possible to enable more of their faces and expressions to be captured. When creating a storytelling album, it is difficult to sell images of the back of the couple's heads. The tears, the laughter and the nervous smiles are all valuable commodities.

Using a fast lens and high-speed film will let you capture the ceremony unobtrusively.

◾ Drag the Shutter

For images at the altar, try dragging the shutter for an exposure of $1/8$ second at f/8. This can be used at just about every church (except for ones with a very dark background). Your images will take on a whole new look!

A talented photographer is always watching, prepared and ready to capture the glances at the bridal party, or a look at the audience.

▣ Private Time

Meshing traditional and contemporary styles can sometimes be tricky for the photographer and the couple working within a limited time span. However, adopting a "private time" concept can eliminate this hindrance. Private time is usually conducted three hours before the ceremony and can be done with the bride and groom alone, or with the entire family and bridal party. During this time away from the crowds of guests, the photographer can take unobtrusive photographs of the couple, family and/or bridal party interacting naturally.

Before you can sell the private time concept, you must have bought into the idea yourself. If you don't believe in it, your clients won't either. Remember, when selling anything, it is important to build the benefit to the buyer.

Benefits of Private Time
1. Pray together
2. Discuss what you are about to do, enjoy each other's company in solitude
3. Spend some time alone, away from the confusion and chaos
4. Take time to freely express emotions
5. Spend less time away from your guests after the ceremony
6. Reduce stress
7. Enjoy this special experience
8. Do all your photographs before the ceremony, get more intimate images

Disadvantages of Private Time

1. You start your day earlier (however, you enjoy it longer)

2. According to the old adage, it is bad luck to see each other beforehand (however, most churches believe it is *good luck* to pray together beforehand)

When the bride and groom see each other for the first time in a more intimate setting than the ceremony, it can be an even more memorable event.

The most common objection is from the bride, who wants to see the groom's reaction to seeing her for the first time. To overcome this, use a statement like:

> I understand wanting to have him see you for the first time—and you, him. However, we have found that most couples don't even remember that experience. As you are walking down the aisle, the bride often can't even see the groom right away. However, even more importantly, you are usually worried about tripping on your dress or your

father stepping on you. The groom typically can't express his emotions, because all he can think about is the hundred people in the church and keeping his cool. With private time, you'll be able to see each other for the first time without all the other stresses, and then spend some very special private time together. You will do much, much more than just gasp as you walk down the aisle.

When private time is scheduled, we select a special private location. When the bride is ready, we stage her holding her bouquet. The groom waits in the corridor (often pacing), until she is ready. Then we ask everyone to leave. The photographer has the bride staged and is positioned discretely in a spot where he can capture both expressions. He then signals on the two-way radios to have the groom enter. The bride's heart starts to pound and the door slowly opens. The groom gasps, and then they hug and kiss. The photographer captures a few quick images as he exits the room.

Private time lets the bride and groom spend some relaxed time alone together on what is otherwise a very hectic day.

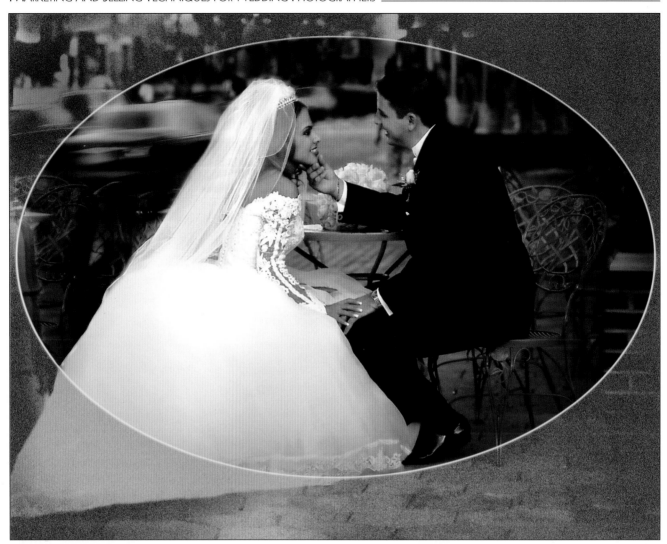

When the bride and groom are ready, they come out of the private time room, and we begin photographing.

We are not really sure what goes on in there. Private time is exactly that—private. I have been told they laugh, they cry, they pray. In the past, we have had clients spend as long as an hour together before exiting the room. We have had couples write us thank-you letters stating that their private time was the most special part of the entire day. As we tell couples, you don't do private time to take better photographs, you do private time to have a better wedding day!

When the bride and groom are ready, they come out and we begin photographing. We usually spend about an hour with them and then have the bridal party meet up with us at the church or other specified location. If possible, we will do the entire posed grouping before the ceremony.

Overall, this service is very advantageous for all parties involved. Using private time allows you to give the client complete coverage, and

diminishes stress for all parties involved. It also allows you to produce and sell more images. One out of every three weddings we photograph now uses the private time concept. Remember, it can be sold if *you* are sold on it.

◼ Personal Bridal Assistant

Finally, to help coordinate the traditional formals and maintain photo relations, you may wish to hire a personal bridal assistant to function as your company's primary public relations representative. A personal bridal assistant is *not* a wedding coordinator or a technical photography assistant. After all, if you are targeting an upscale bridal market, you don't want to step on the toes of the local wedding coordinators or jeopardize the refer-rals they will provide. Moreover, you do not want to lose your own focus on the direction of your photography business. Nonetheless, a personal

The personal bridal assistant can help to relieve the bride's stress throughout the day.

bridal assistant can be available to help schmooze with the key people on the actual wedding day.

The main duty of the personal bridal assistant is to conduct public relations with the bridal party and family members, and make your company look good—thus advertising the high quality of your business. The primary goal of a personal bridal assistant before and during the ceremony is to relieve the bride's stress. If the bride is less stressed, she will be friendlier, and easier to deal with and photograph. This will help you capture more relaxed, enjoyable images. The personal bridal assistant can also make herself available to assist the bride with the important little details of the day, and to coordinate the formals before and after the ceremony. By adding this program, you can significantly increase your pricing level (or packages) with a very modest increase in your own expenses. Some of the key responsibilities of a personal bridal assistant include:

- Assisting with skin care and makeup application throughout the day (reminding the bride to touch up her lipstick and powder, for example)
- Helping the bride with her dress and veil
- Coordinating family portraits after the ceremony
- Possibly dress mending, retrieving breath mints, water, aspirin, antacid, etc.
- Pinning corsages and boutonnieres
- Assisting with signature frame signing
- And much, much more...

The primary function of a personal bridal assistant during the reception is to assist by being the eyes and the ears of the photographer. The personal bridal assistant should also have a two-way radio and can sit back and scope out the reception area, looking and listening to help notify the photographer of an event that may be upcoming. At a recent wedding, while the photographer was setting up to photograph the cake cutting, the grandfather of the bride was dirty dancing with five brides maids across the room! That moment could have been missed. Fortunately, there was a personal bridal assistant who could radio the photographer to notify him what was taking place. It was captured, and is a very saleable image!

Finally, when instituting a personal bridal assistant program, create a section in your interview packet that explains this service. Bear in mind that wedding coordinators charge more for their "day only" services. Since the personal bridal assistant will not be scheduling events, or coordinating the wedding prior to the function, the price you set should be comparable to "day only" wedding coordinator fees in your geographical area. (If clients *do* want help with scheduling and coordinating, you should certainly offer

If the bride is less stressed, she will be more friendly, and easier to deal with and photograph.

referrals to such services at no charge.) A personal bridal assistant's help is extremely valuable in heading off problems before they arise. Often, she will fulfill duties similar to a bridal coordinator, and should be compensated equally. Our interview packet includes the following section:

Personal Bridal Assistant

Your special day will be a stressful one. With your very own personal bridal assistant, you can be assured that your stress will be relieved. From breath mints to dress mending, she will take care of the little things that make a big difference.

Services start at:
$000.00 Ceremony coverage (pre- and post-ceremony)
$000.00 Complete Coverage (ceremony and reception)

Many brides get the urge to work in the wedding industry after planning their own wedding.

When interviewing clients, use your personal bridal assistant option to sell a more expensive package. You can work these services into your package or pricing level setup, or sell them as an add-on. Personal bridal assistant services can also be added as an effective booking incentive for the bridal couple.

When hiring a personal bridal assistant, first consider a wife or significant other. Their services are usually the least expensive. Next, consider a past bride, who may need to make some extra cash on the weekends. Many brides get the urge to work in the wedding industry after planning their own wedding. This is an easy way to hire someone who will be immediately able to relate to the bride and easy to train. Finally, attempt to contact local colleges, and interview marketing or public relations interns. These individuals may be willing to work for you for college credit rather than pay (or perhaps for very little pay). This gives them experience, and is (for most people) much more enjoyable than a part-time restaurant or retail position.

COMPLETING THE CYCLE

Proficiently completing the sales cycle will help make the most of your investment of time and money. As a professional, you invest in advertising and other applicable expenses, but most of all you invest yourself and your time. Making the most of all these investments is very worthwhile. This task can be accomplished by dynamic album design techniques, a compelling focus on frame sales, and successful on-line ordering promotion and publicity. Begin the completion of the cycle by focusing on a dynamic album design system.

▓ Album Design: Working with Customers

There are many different approaches to album design. For example, one can use the standard proofing system (printed proof booklets), or the video preview system. When getting started, it's a good idea to study suggestions from different mentors—but don't get stuck in the "fear of change mode." As technology increases, a successful business owner should grow with the technology. A productive album design system can increase your profits, encourage double album sets, and expedite the album completion time.

We have found it most effective to use a video proofing system. Begin this system by creating proofing videos.

Creating the Preview Video—Avoiding the paper proofing system can save you time and money. You can successfully utilize a videotape proofing system, or a printed contact sheet, or both. To begin, convert your images

Proficiently completing the sales cycle will help make the most of your investment in time and money.

to digital files. The negatives can be scanned with a fotovix or put on a Kodak CD, which retrieves an inexpensive high-resolution scan. To create a contact sheet, use Adobe® Photoshop® or Thumbs Plus 32® (Thumbs Plus 32® can be downloaded from the internet at no cost). When creating a contact sheet, you may find that you prefer to scan all of the images in black & white to avoid messing with time-consuming color management of the thumbnails.

The digital files can then be output to a slide show program called Easy Viewer®. Art Leather also has an Easy Capture® program that will automatically number the images (this program can be downloaded from the Art Leather website). Simply number the scans in sequential order, and group them thematically—the bride's preparations, the groom's preparations, the ceremony, formals, the reception, etc. The resulting "slide-show" video should be created in a PC format using a video capture card. The video card should possess an S-video or RCA line out, which is then connected by a cable to your VCR. The S-video system is preferable and will give your images a higher resolution (more lines per inch) than RCA.

You can create a very effective presentation utilizing two or three decks (simple VCRs linked to one another). This will support the dubbing of up to three videos at once. These videos will be distributed to each set of parents and the bridal couple along with order forms. Next, contact a local tape supplier (a videographer may be able to assist you in locating a contact person). Purchase 120-minute tapes to create the copies. Copy them on standard speed (the noise will increase with slow speed tapes and lowers the quality). Finally, employ a label program to professionally label your tapes. Include your company name, phone number, and website on the video label.

Preparing Local Clients—Once the videos are almost complete, we contact the couple to schedule their album design. Ideally, this process is complete one week from the date of their wedding. When we schedule their album design time, we simply call and say, "Hello, Suzy! How is married life? Did you have a great honeymoon?" After listening to her response, continue, "Fabulous! I know you are excited to see these fantastic images, so let's schedule a time to get together as soon as possible."

We then detail how the process will work. The bride and her husband will need to allocate about three to four hours—the earlier the better. We will have them view their video in our home theater room first, since watching it on our system will give them a clearer, higher quality image. Next, we show them a pre-designed album that we would call the "perfect studio album." Because the bride and groom have probably never designed an album, we help them lay out the format and create a truly spectacular storytelling album, rather than just a scrapbook. They will then go through the album image by image, page by page, to personalize it and create the ideal

Because the bride and groom have probably never designed an album, we help them lay out the format.

wedding album for *them*. Technology is great! Since we do this digitally, with a click of a button, the couple can change the mats and move the images as they like. They can also see exactly what the album looks like before it goes to production!

The time the couple spends on the album depends upon the changes they make. Some couples can have their album completely designed in two hours (bear in mind that it will take approximately an hour to preview the video). Some of our couples take a little longer. We request that couples allocate three or four hours, just in case. This is much easier than taking the time to get back on track if they must leave before the session is complete. In addition, when they leave our studio, they go with a finished album design and a printout of it. They also leave with three duplicate preview videos (for themselves and their parents) and additional order forms.

The next day, their order is pulled and sent to the lab. The finished album is then delivered in about six weeks, typically only two months after the wedding date.

After explaining all of this to the bride, get some verbal feedback, then proceed to scheduling an appointment. Listed below are some questions to ask (and some possible responses) to help you find a mutually beneficial time for the album design session.

Photographer: So, what is best for you—morning, afternoon or evening?
Bride: *(record her response)*

Photographer: The beginning of the week or the end of the week?
Bride: The weekends would be best.
Photographer: Well, you know, Saturdays are very busy for us and Sundays are typically our only day off, so if it has to be a weekend our next morning opening isn't until_____. I would hate for you to wait that long to view your images. Could you and your husband leave work a little early on a Friday afternoon?

Bride: The evening is best, beginning of the week.
Photographer: Great! What is the earliest time you can be here? How about Monday, the 14th at 5:30p.m.?
Bride: I don't think we can be there until 7:00pm.
Photographer: We need to make it a little earlier. We have found that the later you arrive, the more tired you get, and you just can't design a quality album. After all, you want to be at your best. This is a family heirloom that will be passed down for generations. Is there any way you can talk to your husband and see if you can adjust your schedules to be here by 6:00pm?

> The time the couple spends will vary depending upon how many changes they make.

Bride: Can't we just take the videos home to review them and decide which images we want before we design the album?
Photographer: I am sorry, but that is just not our policy. I can't let the videos leave the studio until your album design has begun.

Do not let the videos leave the studio until the album design has begun. If you are stern about your policy and do not make exceptions, your client will accept that. The day the client first views the video, the images possess a higher emotional value to them. Thus, they are willing to spend more. If you allow the videos to leave the studio, they take them home, analyze the individual pieces, and begin to narrow it down to a select few images. They are no longer emotionally attached; they now become practical about their decisions. Something as important as the documentation of their special day, should be an *emotional* buy, not a practical one.

Preparing Out-of-Town Clients—Once the videos are almost complete, we contact the couple to begin the album design process. Ideally, this process is complete three weeks from the date of their wedding. The process takes longer than for local clients because we must send the couples their three preview videos, a letter with instructions for them to follow, and a sample album design.

When we submit their album design package, we call first and explain it. An example of a typical conversation follows:

Photographer: Hello, Suzy! I hope married life finds you well! How was your honeymoon?
Bride: (her response)

Photographer: Great! Well, I know you are excited to view these incredible images. I know you will be very pleased.

This is what we are going to do. First, I will be mailing you a package with three duplicate preview video tapes. One is for you, the others are for each set of your parents. Feel free to duplicate them as many times as you wish—send them all over the world, if you like!

We will also be sending you a sample album design. We have designed what we would consider the "perfect studio album." What you need to do is sit back and watch the video in private. Do not go through and pick out the images you want. It is too difficult that way, and you probably will not get a complete story line. However, do go through and jot down the numbers of the images you never want to see again!

Once you have made a list of the images you do *not* want to see again, give us a call. At that time, you can walk through your album

Once the videos are almost complete, we contact the couple to begin the album design process.

design to create a perfect storybook of your special day.
Bride: (her feedback)

Photographer: Great! I am going to put the package in the mail today. Give us a call at 1-800-555-0000 to discuss it further and get your design processed. Remember, do not delay—we're very busy. A delay would cause your album to get dropped from our production schedule. If we have to reschedule, it could detain your final product by months.

On the following two pages you'll find samples of two letters we use in the album design phase with out-of-town clients.

An image of the cake is an important setup image in most wedding albums.

YOURTOWN PHOTOGRAPHY

www.YourtownPhotography.com
5555 Main Street
Yourtown, FL 55555

January 25, 20XX

Diane and Steve Smith
555 Matrimony Lane
Yourtown, FL 55555

Dear Diane and Steve:

Hello! Hope married life finds you well. Sorry about the delay—we have been extremely busy since the first of the year.

We have designed what we consider the "perfect studio album" for you! Now that we have begun the process, you can modify it to fit your personality and taste. This way, you are not on your own in designing it. After all, our photographer is more experienced at album design than most of our couples.

1. We are including a sample printout of your album design; however, it just shows small thumbnails of the images. Please use your videotape, if needed, to see the images more clearly.

2. Keep in mind that our goal is to design a nontraditional album. We want to create a "storytelling album." Therefore, some of the images are required to tell the complete story of your day.

3. If there are any corrections that need to be made, please contact us. It is easiest to discuss these matters over the phone. You can reach us at 1-800-555-0000 to discuss the details.

I look forward to hearing from you and I am sure you will be delighted with your album. The images look fabulous!

Sincerely,

John Doe

YOURTOWN PHOTOGRAPHY

www.YourtownPhotography.com
5555 Main Street
Yourtown, FL 55555

January 25, 20XX

Barbara and Eric Smith
555 Chapel Lane
Yourtown, FL 55555

Dear Barbara and Eric;

Hope married life finds you well! We have designed what we consider the "perfect studio album" for you! This way, you are not on your own designing it. After all, our photographer is a lot more experienced in album design than most of our couples.

1. You may wish to call the office directly when you receive this package. It may be easier for us to walk you through all of your options over the telephone. We can be reached at 1-800-555-0000.

2. Keep in mind that our goal is to design a nontraditional album. We want to create a "storytelling album." Therefore, some of the images are required to tell the complete story of your day. You had a very unique and special story line, so more images were required to tell it. Because each page has two sides, if you chose to eliminate one side, you must eliminate a total of two. Remember, the more you eliminate, the less likely people will be able to share the emotions and follow your story.

3. Our records indicate that you have a $1500 album credit included with your level. The total cost of the "perfect studio design album" is $3306.30. With your $1500 product credit, your $150 album credit, and your $105 tax credit, **the balance is $1551.30**, if you purchase the album as we designed it for you. We require 50% down before we begin processing your order. It usually takes two to three months to complete an album design order. The remaining balance will be due upon completion. Please make any additional changes as quickly as possible and fax or mail the form back to the studio. **REMEMBER, your contract only locks in the prices from the time of the contract signing until two months after the wedding. Our 4"x5", 5"x7", and 8"x10" prices have increased by $5.00 in the last year.** Because of this, we need to have your changes back by month end.

4. If there are any additional images that need to be made, indicate them and complete an order form. We can be reached by phone, fax or email (1-800-555-0000, fax: 1-800-555-0001 or johndoe@ YourtownPhotography.com) to discuss the details.

I look forward to hearing from you and I am sure you will be delighted with your album. The images look fabulous! Give our secretary a call this week to set up a time for your album design.

Sincerely,

John Doe

❊ Album Design: The Design Process

Once the preview tape has been reviewed, the album design can begin. To begin this process, first discuss with the couple their album preference, as well as the styles and colors they want.

Color Harmony—Counsel your client about color harmony. You should point out that black works especially well because it showcases the images without conflicting with the colors of the dresses, flowers, etc. Also, use caution when combining black & white with color images. Black & white and color images can be combined on facing pages, but do not be excessive with this technique. They should never appear on the same page.

Print Sizes—Remember, when designing a montage layout, the size of the images will be established by the image itself. Mostly 3"x5"s, 4"x5"s and 5"x7"s will be used to design the storybook album. Reserve the 8"x10"s and the 10"x10"s for posed groupings and momentous events—like the cake shots, the first dance, and the toast.

Grouping and Organizing Prints—When grouping images, strive for an arrangement where each action has a reaction. For instance, pair a photo of the bride dancing with her dad with a photo of the bride's mom crying.

The successful storytelling album designer wants to lead the viewer's eyes into the album and keep them there. Using the bookend concept can

Digital technology allows the album preview to be created, viewed and edited on screen.

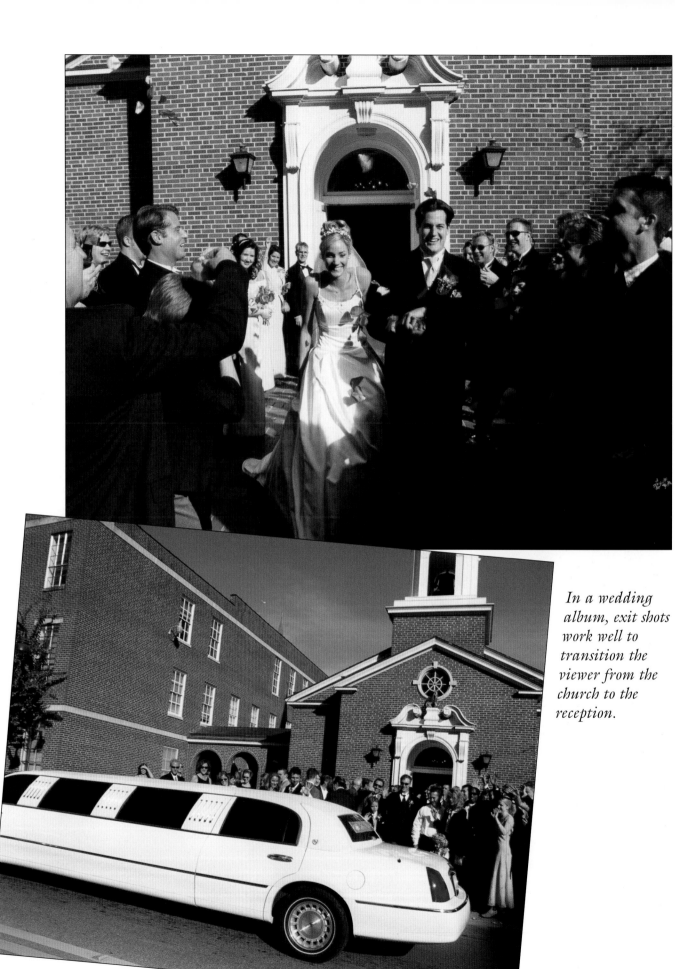

In a wedding album, exit shots work well to transition the viewer from the church to the reception.

help to achieve this. Bookending simply means making sure each image looks *into* the page (toward the spine), like bookends. This leads the viewer into the center of the pictures, not outward and off the page.

Continuity—You should also arrange the images with continuity to lead the viewer where you want him to go. Using the appropriate setup shots can help you orient the viewer and lead him into the next event. During the wedding, keep an eye open for images to use as setup shots—an image of the cake can introduce the reception, a photo of the church can introduce the ceremony, etc. To introduce the couple arriving at the reception from the ceremony, try using an image of the room setup at the reception site. This tells the viewer that something is about to change.

Using the appropriate setup shots can help you orient the viewer and lead him into the next event.

▩ Trial Closes

Throughout the album design process, remind the clients of the importance of a unique storytelling book. While you are designing it, make suggestions on images and ask trial close questions. Always ask a minimum of five trial questions per design. These pre-close questions can include:

- Are you beginning to see the importance of using these detailed images to tell the story of your day?
- How do you like it so far?
- Isn't this wonderful? Wow, it looks incredible!
- Isn't this exciting, seeing the story unfold?
- Aren't you excited about showing your storybook to someone that couldn't be there with you and having them relive your day?
- Do you see how this fits together?
- Don't you just love that series of images?

Educate your client on the storytelling process the whole way through the design. Each time they answer yes to one of your pre-close questions, they are closing the sale themselves. If they object to the album upon completion, you will know it is strictly a financial objection. Throughout the design process, you should make statements such as, "We want you to have the perfect album. It is a family heirloom and will be with you for a lifetime. We want it to be exactly the way you want it. I am here to help you any way I can. Let's just focus on making this perfect for both of you."

Once you have designed a perfect album, using setup shots, bookending techniques, and action/reaction techniques, it is time to begin closing the design. You may want to suggest that the couple separate the formal section of their album from the storybook section. The only added cost is for is an additional cover, and this separation will provide their viewers with the easiest way to view their album.

Price—Do not go over price with your client during the album design process. If you do, they will scale back and start making their decisions based on finances instead of emotions.

If they ask you how much something costs, your response should be something like, "That's really difficult to say right now—each album varies greatly. Let's just walk through and finish it perfectly. Then we can go back through and tweak it as needed. Just keep in mind that if you eliminate one page you have to eliminate two. In order to make a big dent to lower the cost of the album, you will have to cut out a lot of the images. That could disrupt the storytelling concept." It is important to emphasize the quality of the album. Tell the client, "We want you to have the perfect album. It is a family heirloom and will be with you for a lifetime. We want it to be exactly the way you want it. I am here to help you any way I can. Let's focus on making this perfect."

Once the album is completely designed, ask them another trial close question such as:

- So what do you think?
- Don't you just love it?

Then click over to the invoice summary page. Show the total amount of pages and prints. Indicate and deduct their credit. Show the client the balance due. They will probably be sticker-shocked! Typically, the balance will be $1000 to $3000 over the initial investment. Respond, "Don't worry! We can break this into two or three payments—whatever is easier for you." *Don't* tell them that you can go back through the album and redesign it—they already told you they love it just the way it is. If they make changes at this point, it is all about money!

If they are still hesitant after hearing the payment options, you can respond, "I know you love the album exactly the way it is. Instead of going back through and ripping it apart and taking out all of those images that you just told me you liked, let me see what I can do." Then pause and review the figures.

Once you've reviewed the numbers, offer them a slightly reduced price. Your statement might be something like, "If you accept the album just like it is, I will deduct X dollars from the 3"x5" and the 4"x5" price." (Subtract $3, $4, or $5 from each of the images.) "That will lower the cost from $15.00 each to $12.00, and save you $300.00.

> The important point is to emphasize the quality of the album.

> ### ▦ Engagement Portrait Sessions
> Establishing a complimentary engagement portrait session helps initiate a rapport with couples booked a year or more in advance. More contact with the couple prior to the wedding day helps to cement that relationship. It also gives the photographer a chance to study the couple's height differences, interaction with each other, and personal insecurities. The engagement portrait or "Love Portrait" will also help determine if they are "picture people" or not. This should give the photographer an indication on how much and what type of images to focus on at the wedding and during the album design.

How does that sound to you? Whatever you prefer is perfectly fine with me." We typically make the deduction from the 3"x5"s or 4"x5"s because they constitute the bulk of the images, and the place where most of the money is spent. It is also the first section clients tend to delete. Once you make that subtraction, you'll find that the client will usually go with it. This simple technique can increase your album design sales by thousands of dollars (over having the clients pull those images) and drastically increase your profit potential while providing the client with the best possible album.

❖ Focus on Frames

Framed work is artwork, and art sells! A studio profits the most from frame sales when marketing the frames from the beginning of the relationship with the couple. Using a complimentary engagement session can boost your frame sales before the wedding day; it is a great way to heighten your company's profits. Shortly before the wedding (and immediately after),

If you can schedule an engagement session, you'll make a sale when your clients have the most cash.

each dollar is usually budgeted. This means the client is less likely to buy in high volume at these times. If you can arrange an engagement portrait well in advance of the wedding, you'll catch your clients when they have the most cash, the least amount of stress, and the highest level of enthusiasm!

Designing the Perfect Love Portrait—Contemplate sending a checklist to all of your recently contracted clients. An example of this basic checklist for preparing clients for a Love Portrait session is included on page 66.

Increasing Frame Sales—Once you have taken the portrait (regardless of whether it is an engagement portrait, formal portrait, or wedding day image), show your work in the frames you sell. Try picking out your favorite proofs and placing them in a small wall folio. Not only will your images be showcased in style, you'll be encouraging your clients to buy custom-framed folios instead of single prints for mom and grandmother. These are gifts that will last a lifetime.

In order to successfully increase your frame sales, rethink the setup of your studio. Ask yourself the following questions:

1. Are your displaying your images in the frames you want to sell?
2. Do your custom-framed images have price tags on them? When touring a client are you just selling your work, or are you selling your work in frames?
3. Are your studio samples outdated?
4. Are you showcasing samples that will appeal to all markets? Traditional cherry, classic gold, silver, contemporary black and white, etc.?
5. Do you change your prints and your contemporary frames at least once a year.

When selecting a framing company, look for one that provides an impressive, high-class image. Be cautious not to sell only the products that appeal to your personal style. Just because *you* may be partial to the contemporary black frame and black & white print does not mean that it will fit in with every client's décor. Showcase a variety of frames in oak, whitewash, cherry, gold, platinum, and contemporary black & white. If your studio is large enough to show a little bit of everything without seeming overcrowded, you are much more likely to appeal to a wider audience. Upgrade your frames regularly; they portray your image. A poorly constructed or outdated frame can be detrimental to your otherwise fabulous image.

Frame sales *do* require an investment because this is a case where the eye buys. You need to have samples to show in order to make the sale. Is it worth the initial investment? Well, if you have thirty weddings per year and

Contemplate sending a checklist to all of your recently contracted clients.

Many clients purchase a signature frame featuring their engagement portrait.

sell $150 worth of frames to one person in each couple (including the bridal couple, parents, bridal party, grandparents, etc.) that means $4,500 extra income. This assumes that each couple only buys *one* very small frame. On average, bridal couples will buy more than one. Many will spend in excess of $150.00. Additionally, investing in sample frames is worth the investment for your professional image alone.

Selling Points—When selling frames to your couples ask them questions such as:

- What is the décor in your home like?
- Where will people view your image?
- How will it be displayed—on a desk or on a wall?

A beautifully framed and matted engagement portrait can be displayed at the reception.

Try to sell your clients on the concept of harmonizing with their furniture and décor. Frames are not considered expensive if they are looked at as wall furniture. Paint a picture for your client—help them to see the image hanging on their wall, and your product is sold. Ask them to visualize it hanging in their living room, and help them see it as a family heirloom—this will build the value of their purchase. Photography will no longer seem expensive, it will seem priceless!

Signature Frames—As an added bonus, suggest the couple consider a signature frame. Their beautifully framed portrait will greet their guests as they arrive at the reception and allow the couple's friends and families to sign a personalized message to the bride and groom. The complete kit includes: the designer frame, a signature mat customized with the couple's name and wedding date, one custom 11"x14" portrait (or the three 5"x7" openings), a gold/silver pen, and a custom gift box easy for transportation.

Pricing—It is important to establish a pricing structure for all your framed images. 4"x5", 5"x7", 8"x10" and 10"x10" prints may be purchased one by one at a fixed price. However, all prints 11"x14" or larger should be priced as a custom-framing job. Taking control of framing helps you determine how your work will be showcased. If a client resists the already-framed pricing structure and wants a quote for an unframed image, try responding as follows:

Suggest

the

couple

consider a

signature

frame.

"We can't guarantee the image if you frame it outside of our company. This is due to the fact that mounting the print against cheap material can adversely affect it. However, if we frame the image, it will be done properly. If something should happen to the print because of the way it is protected, it will be replaced. You cannot afford not to have your print protected."

Frame Promotions—Consider increasing your frame sales by creating promotions for the grandparents, parents, and bridal party. Target these parties directly by having your couples complete a wedding worksheet indicating the names and addresses of their maid of honor and best man, parents, and grandparents. Currently, people are investing less in parent albums. They want quick results—parents don't want to spend hours pouring through a child's wedding album. To these parents, you may want to promote a wall folio collection with an 8"x10" and 4" x5"s or 5"x7"s. This is also a good option to suggest to families who didn't

You can offer special frame promotions with three- and four-image wall folios.

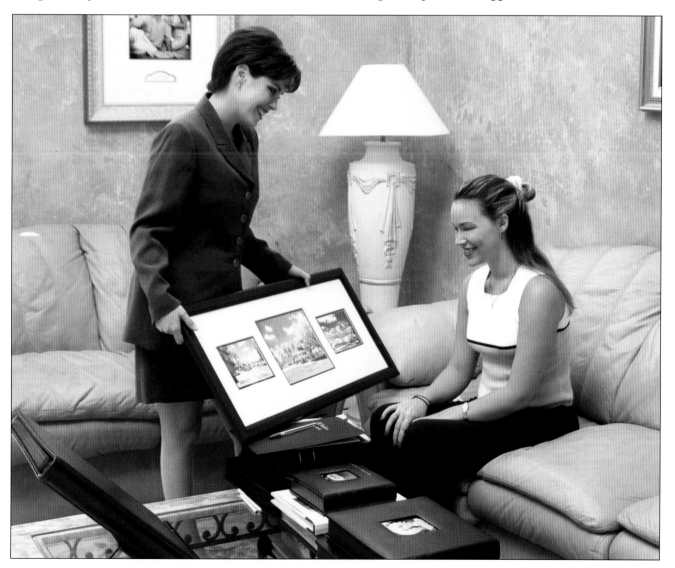

purchase an album for another child's wedding and don't want to favor the new couple.

Christine Perry-Burke from Art Leather/Gross National Product suggests considering the following frame promotions:

Pick 4: A Winning Combination

Our new Pick 4 wall folio lets you pick your favorite four poses and have them beautifully framed and double matted for one low price. It is a gallery of treasured memories that will bring you years of enjoyment. *4 poses and 4 opening wall folio 4 one low price—only $000.00.*

I Love You Three Ways: For Grandparents Only!

Children have many moods and expressions that bring smiles to grandparents' faces. Now you can capture those wonderful moments in a beautiful three-pose gallery frame specially priced for you. Pick your three favorite poses and we will double mat and frame them for years of enjoyment! *Three 5"x7" portraits and wall folio frame—only $000.00.*

On-Line Ordering

Continue to increase your sales by instituting an on-line ordering program. Because it can be accessed by the couple's friends and family around the world, this will increase the flow of traffic onto your site and increase your outside orders. Because this provides a service to the customer as well (reducing their effort in showing proofs to everyone who wants to order photos), you should consider charging customers for placing their proofs on-line. Create a specific price for engagement proofs on-line, and an additional price for wedding images. However, we do suggest having the number of the images, the selection of the prints, and length of on-line visibility selected at the discretion of the photographer. This will allow you to choose what is displayed, how long it is displayed, and how much it costs. For more information on on-line ordering, contact <MorePhotos.com>.

The cost for these programs is minimal and the response can be incredible. You can promote this service in your information/interviewing packet as follows:

This will increase the flow of traffic onto your site and increase your outside orders

On-Line Ordering

To help make ordering easier for your friends and family members, you can now display a selection of your images on-line! Display up to 100 of your favorite images from your special day on our

website. For your reception, you will receive a special tabletop thank-you card with instructions to each of your guests and your own special password. You will receive your personal code to allow private access only to your selected visitors. Image selection will be determined at the discretion of Yourtown Photography.

For a sample of our on-line ordering promotional flyer, see page 52.

▦ Publicity=Profits

Keep the ball rolling and the publicity flowing! You have created a fantastic client. You have worked with them full circle to give them high quality service in an expedited fashion. Now, you can keep the promotions flowing and maintain customer service to develop a client base that will continue for a lifetime. Use the following procedure to ensure you take every opportunity to connect with your clients and generate additional sales.

Develop a client base that will continue for a lifetime.

1. Immediately following the wedding, send thank-you notes to the key players—typically, bridal couple and their parents.
2. Always send anniversary cards.
3. Don't forget the holidays! Hold a Christmas family portrait special, conduct a Mother's Day parent album special, or a Father's Day folio promotion.
4. Don't forget about your wedding vendor contacts—send out complimentary engagement portrait session cards for Valentine's Day.

The forms on the following pages are samples of some promotional mailings used to increase publicity and build sales. Try adapting these ideas to suit your business—or as a starting point for developing your own creative publicity strategies!

Enter to be selected in the
Millennium Bridal Makeover Contest
and you could be
a model for a day!

You will be pampered with first-class treatment
from some of the top wedding professionals in the area.

SPONSORS INCLUDE:

Yourtown Photography	*Natural Beauty Salon*	Carriage House Limousine	Blossom Floral Design
Receive a free bridal portrait session with a premier wedding photographer	Be pampered with a makeover and hairstyle for your photo session	You and a guest will arrive in style in a first-class limousine	Receive a fabulous bouquet to enhance your beauty and add pizzazz to your portrait

To Enter the Millennium Bridal Makeover Contest...

1. Reserve your wedding date at the country club between October 15, XXXX and January 30, XXXX.
2. Complete and mail the attached registration form. (See back for details.)

---cut here ---

Bride's name: _____ Groom's name: _____

Address: _____

Home phone number: _____ Reception location: _____

E-mail address: _____ Wedding date: _____

Contest Rules:

One entry per bridal couple. Submit completed entry form by January 30, XXXX. Your name, contact number, reception location and wedding date must be on the entry form. Entrant must turn in entry form to: Yourtown Photography, P.O. Box 1111, Yourtown, Florida 55555.

• Contest begins October 15, XXXX. Mailed entries must be postmarked by January 15, XXXX and received by January 30, XXXX.

• All entries and photographs become the property of Yourtown Photography and will not be acknowledged or returned. (Yourtown Photography will not be responsible for lost, illegible, late, incomplete, postage due, or misdirected mail or entries.)

• One Grand Prize Winner will be selected. The winner will receive a makeover, hairstyle, formal bridal portrait session, and limousine service to and from the photo shoot. Services must be used in conjunction with the terms and conditions the sponsors specify. Date, time, and location will be subject to the discretion of Yourtown Photography and the other applicable vendors.

• Display portrait will be chosen by a panel of photography experts based on the degree and quality of the image and the overall appearance of the person pictured.

• Contest is open to brides 18 years or older as of October 15, XXXX, who are legal U.S. or Canadian residents, except employees and immediate family members of the companies involved and their subsidiaries, divisions and related companies and their respective agencies and agents, and contest experts.

• Prizes are not transferable and may not be substituted or redeemed for cash. All prizes will be awarded provided a sufficient number of qualified entries meet the minimum standards established by the criteria.

• Yourtown Photography and its subsidiaries, divisions and related companies and their respective officers, employees, or representatives are not responsible for and will be held harmless by all winners against any damages loss, injuries cost or expenses to person including death, and property due to acceptance, possession, use or misuse of a prize by participating in this contest.

• Winners will agree to grant Yourtown Photography, the applicable reception site, and its advertising/promotion agencies the right to use their names, likeness, and photographs and the right to adopt, publish, and use their entries and any other materials resulting from and developed in the course of this promotion for any advertising, promotional, trade or any other purpose without compensation or permission, except where prohibited by law.

• Grand Prize winner will be notified by phone or by mail no later than February 15, XXXX.

• All Federal, state, provincial and local taxes (and travel expenses if applicable) are the responsibility of the winner. Contest is void where prohibited, taxed, or restricted. Winners may be required to execute and return an affidavit of eligibility and publicity, liability and other release forms, where lawful, within 5 days of notification or an alternate winner will be selected. Winner's travel companion may be required to sign and return a liability and publicity release, where lawful, prior to travel, and if a companion is a minor, minor must travel with a parent/legal guardian who must sign the release on the minor's behalf. Prize notifications returned as nondeliverable will be forfeited and an alternate winner selected. Any litigation respecting the conduct or organization of publicity may be submitted to the Regie des Alcools des courses et des jeux for a ruling. Any litigation respecting an awarding of a prize may be submitted to the Regie only for the purpose of helping the parties reach a settlement.

• Entrants need not purchase services from the photographer, florist, or limousine companies involved in the contest listed

Postcards make great holiday and special offer mailers!

PARENT ALBUM SPECIAL

Here at Yourtown Photography, we understand the importance of documenting special family moments in history. So, to help you celebrate Mother's Day and as a special thank-you gift for you, you can receive a

Medium Futura Designer Parent Album
including sixteen 5x7 prints for only $375!

This unique item is available in several popular colors and normally costs $475—you save $100. Call us today at (555)555-0000 or (800)555-0000 to design your special album. Offer Expires May 30, XXXX.

YOURTOWN PHOTOGRAPHY

Gift Certificate
For a FREE Environmental Family Portrait Session
$150 Value

TO: _____

FROM: _____

Authorized by: _____ *Expires:* _____

Not redeemable for cash. Date, time and location at the discretion of Yourtown Photography.

www.YourtownPhotography.com *(800)555-0000*

YOURTOWN PHOTOGRAPHY

To help you celebrate Valentine's Day,
we would like to offer you a

Complimentary
Environmental Family Portrait Session!

We want to be a part of your special family moments in the years to come, so as a thank-you to you, our friends, this $200 session is yours free! Call today—dates and times subject to availability!

Offer expires May of XXXX. Date, time and location of shoot subject to the discretion of Yourtown Photography.

▨ Working the Circle Together

As the saying goes, there is no "I" in "team." Strength comes in unity. Consider hiring production, technical, office, marketing and photography assistants to help complete the cycle.

See the following job descriptions to determine which positions (and help in which phase of the cycle) will best assist you in your endeavors. Though the number of employees, and the duties performed by each, will vary greatly based on the size of the business, the location, and the marketing demographics, these positions are all very valuable.

As in everything you do, strength comes in unity.

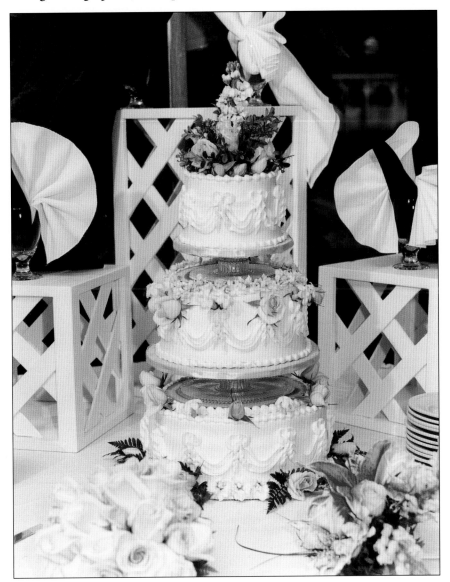

Behind every wedding image that is made and sold is a team of professionals working on every step of the circle.

POSITION: MARKETING DIRECTOR

HOURS: Minimum 30 hours per week required
REPORTS TO: John Doe, Owner

DUTIES INCLUDE:

1. Pose as the primary public relations representative
2. Coordinate all correspondence with prospective clients
3. Schedule interviews
4. Follow up with all e-mail correspondence and inquiries
5. Conduct client interviews
6. Bridal show liaison (work bridal show exhibits and follow up with leads)
7. Attend networking functions
8. Initiate vendor referral
9. Create company press releases
10. Launch yearly promotions and contests
11. Establish a bridal follow up program
12. Schedule client album design sessions
13. Oversee activity of the production, technical, and office assistants
14. All other duties as deemed appropriate and specified by owner

I accept all the above duties and job requirement and will fulfill them to the best of my abilities. I realize it requires a team effort to conduct the mission of Yourtown Photography and will display a team spirit and professional attitude and image.

_____ _____
Employee Signature Date

POSITION: PRODUCTION ASSISTANT*

HOURS: Minimum 15 hours per week required
REPORTS TO: Jane Doe, Director of Operations
OVERSEES ACTIVITIES: John Doe, Owner

DUTIES INCLUDE:

1. Production assistant is required to work closely with the technical assistant
2. Cut negatives, verify numbering
3. Pull orders, send to lab, verify corrections
4. Document the status of all orders in the computer
5. Periodically double-check the status of orders
6. Number prints
7. Assemble albums
8. Notify director of operations when orders and albums are complete and ready for pickup
9. Update and order mats
10. Fax album order to supplier
11. Assemble interviewing packets
12. Keep client status forms up-to-date
13. Prepare thank-you notes for clients after their album is complete
14. Answer the phones and doors, and assist with clients when necessary
15. Take turns with technical assistant to empty trash at end of day
16. File Yourtown Photography receipts
17. Place completed order folders on top shelf in closet
18. Place single orders on the shelf on the left of closet
19. Monitor airborne shipping, send orders daily
20. All other duties as deemed appropriate and specified by the director of operations or the owner

*Please bear in mind the technical assistant and the production assistant positions are designed to be a job-sharing position. Duties and positions may be switched to create a cross-training program within the organization.

I accept all the above duties and job requirements and will fulfill them to the best of my abilities. I realize it requires a team effort to conduct the mission of Yourtown Photography and will display a team spirit and professional attitude and image.

_____ _____
Employee Signature Date

POSITION: TECHNICAL ASSISTANT*

HOURS: Minimum 15 hours per week required
REPORTS TO: Jane Doe, Director of Operations
OVERSEES ACTIVITIES: John Doe, Owner

DUTIES INCLUDE:

1. Technical assistant is required to work closely with the production assistant
2. Required to pull client folder or create one if necessary
3. Begin client status sheet and oversee completion
4. Organize images when orders are returned from lab
5. When scanning is begun, gives director of operations estimated completion time on videos, so album session can be scheduled
6. Edit and number all images
7. Scans images
8. Create three client preview videos, labels and covers
9. Print labels for preview videos, promotional videos
10. Copy promotional videos
11. Print Yourtown Photography labels and lab identification labels
12. Take turns with the technical assistant to empty trash at end of day
13. Place completed order folders on top shelf in closet
14. Place single orders on the shelf on the left of closet
15. Answer the phones and doors, and assist with clients when necessary.
16. All other duties as deemed appropriate and specified by the director of operations or the owner

*Please bear in mind the technical assistant and the production assistant positions are designed to be a job-sharing position. Duties and positions may be switched to create a cross-training program within the organization.

I accept all the above duties and job requirements and will fulfill them to the best of my abilities. I realize it requires a team effort to conduct the mission of Yourtown Photography and will display a team spirit and professional attitude and image.

_____ _____
Employee Signature Date

POSITION: WEDDING PHOTOGRAPHY ASSISTANT*

HOURS: Weekend, wedding hours required
REPORTS TO: John Doe, Owner
OVERSEES ACTIVITIES: Jane Doe, Director of Operations

DUTIES INCLUDE:

1. The photography assistant is required to work closely with the photographer and the personal bridal assistant
2. Assist in maintaining a positive professional image on the day of the wedding, while providing adept customer service and, thus, effective public relations
3. Inventory and organize equipment, maintain site and equipment control on location
4. Responsible for metering lights
5. Load film backs
6. Set up auxiliary lights
7. Assist in coordinating formal portraiture
8. Examine and assist with details of posed images (i.e., bride's dress, flowers, etc.)
9. Pack, load, and unload equipment
10. All other duties as deemed appropriate and specified by the director of operations or the owner

*Please bear in mind the photography assistant position works in a triangular fashion along with the technical assistant and the production assistant positions and is designed to be a job-sharing position. Duties and positions may be switched to create a cross-training program within the organization.

I accept all the above duties and job requirements and will fulfill them to the best of my abilities. I realize it requires a team effort to conduct the mission of Yourtown Photography and will display a team spirit and professional attitude and image.

_____ _____
Employee Signature Date

POSITION: OFFICE ASSISTANT*

HOURS: Minimum 15 hours per week required
REPORTS TO: Jane Doe, Director of Operations
OVERSEES ACTIVITIES: John Doe, Owner

DUTIES INCLUDE:

1. Office assistant is required to work closely with owner
2. File receipts
3. Enter accounting information
4. Organize album design room
5. Follow up with production required by owner
6. Document the status of all orders in the computer
7. Update client status sheets
8. Track production in office
9. Periodically double-check status of orders
10. Fax album order to supplier
11. Assemble interviewing packets
12. Prepare thank-you notes for clients after their album is complete
13. Answer the phones and doors, and assist with clients when necessary
14. File completed order folders
15. Organize past client folders and commercial accounts
16. Monitor airborne shipping, send orders daily
17. All other duties as deemed appropriate and specified by the director of operations or the owner

*Please bear in mind the technical assistant, production assistant and office assistant positions are designed to be job-sharing positions. Duties and positions may be switched to create a cross-training program within the organization.

I accept all the above duties and job requirements and will fulfill them to the best of my abilities. I realize it requires a team effort to conduct the mission of Yourtown Photography and will display a team spirit and professional attitude and image.

_____ _____
Employee Signature Date

Employee Guidelines—For employees who will work in a residential setting, it is especially important to set guidelines such as these. Of course, yours will be tailored to the unique needs of your business.

Employee Etiquette: All employees are required to maintain professionalism while conducting the required duties as stated in the appropriate job description. Emphasis on team interaction is required.

Dress Code: A casual but professional attire is required at all times. Even if the assigned position doesn't require continuous people contact, professional attire should be maintained. Keeping in line with the team interaction concept, all employees should be able to assist with customers as deemed appropriate by management and maintain the image established by Yourtown Photography. Shorts and jeans should be avoided. Dress slacks, khakis, dresses and skirts are preferred. Hair should be neatly groomed. Because of our close working conditions, perfume should be kept to a minimum. If attire is a concern, Yourtown Photography shirts can be provided to be worn with black dress slacks or khakis.

Breaks: For every five hours worth of labor a thirty minute break should be taken. Documenting a thirty minute break is not required. However, if you prefer to take an hour lunch break, documentation is necessary. Smoke breaks are not permitted.

Scheduling: Yourtown Photography will work with your schedule when possible. Nevertheless, we do require an established time schedule. Please notify us of any schedule changes within 24 hours of your shift. Furthermore, schedule modifications should be established with the approval of management as far in advance as possible.

Time Sheets: Time sheets are located in "in basket" on the production assistant's desk. Each time sheet covers a two-week period. Please complete your sheet and set it on the owner's desk. Any unethical practices involving timesheets will result in immediate termination. Paychecks are distributed every other Friday.

Phone Etiquette: When available, the owners will most likely answer the phone calls. However, if we are occupied, your assistance is required. Please keep in mind that because we have a home-

Even if the assigned position doesn't require continuous people contact, positive professional attire should be maintained.

based business, your schedule may not always be the same as ours. Just because *you* are working does not mean that *we* are working. If we are not in the office, we are not available. When the production and technical assistant are working together, the production assistant should answer the phone.

Don't
- You should *never* reveal to a client anything personal (i.e., so-and-so is in the shower, taking a nap, exercising, etc.). That is irrelevant and none of their business!

- You should *never* give a prospective client prices over the phone.

- Only give cellular phone numbers to clients if it is extremely important. Never give someone our cellular phone number if they want wedding photography information or wish to schedule an appointment. Simply take down their message.

Do
- Answer the phone by saying, "Good afternoon, Yourtown Photography, can I help you?"

 If the person they wish to speak to is available, please say, "Hold on just one moment, may I ask what this is in regards to?"

 If the person is unavailable, please say, "I'm sorry, he/she is unavailable at the moment. May a take a message and have him/her get right back to you?"

- Take a detailed message on the message pad. Call our cellular phone, if you feel an issue needs to be addressed quickly.

- Be friendly, courteous, and professional.

- Keep personal phone calls to a minimum.

- Push the hold button before talking to us about who is on the line.

CLOSING THOUGHTS

You have

three options:

fix it,

live with it,

or get out

of it.

A WISE WOMEN ONCE SHARED THE GOLDEN PHILOSOPHY OF LIFE. She said that in every situation, you have three options: fix it, live with it, or get out of it. When examining your business, we challenge you to evaluate this golden philosophy. Fix it and make your business better, live with it and accept things for how they are and how they will always be, or get out of it and become a part of something you love.

Wedding photography is a privilege. You are documenting a very important part of your clients' lives and becoming a very important part of their future.

As wedding photographers, our mission is to maintain outstanding public relations and excellent customer service, while attempting to capture a superior bridal market. Our goal is to photograph and immortalize the special moments in the lives of discerning couples. We believe photography is one of the most important aspects of their entire wedding day.

Now that you've started down the path, take a few minutes to look at the questionnaire on the following page. If you can't sincerely answer "true" to every question, work harder to improve those areas. Check back regularly to ensure that (from a client's point of view) you are doing everything you can to win clients and keep their business for life.

We hope this guide helps you follow your mission, your passion, and your dreams.

Let's pretend you are your client...

Answer TRUE or FALSE

1. My photographer always delivers my product in a timely manner.
2. My photographer introduces me to new products regularly.
3. My photographer calls me regularly, and returns my calls promptly.
4. My photographer sends me an anniversary card every year.
5. My photographer sent me a thank-you card for my business.
6. I get a newsletter or notice of seasonal promotions from my photographer.
7. My photographer always looks professional when I do business with him/her.
8. My photographer has offered to conduct family and baby portraits.
9. I feel confident referring my friends to my photographer.
10. My photographer is passionate and enthusiastic about his/her work.
11. My photographer has high ethical standards. His word is his bond.
12. My photographer provides me with good customer service and makes me feel special.

ABOUT THE AUTHORS

JEFF HAWKINS has been a professional photographer for over twenty years, served as Public Relations Director of the Wedding Professionals of Central Florida (WPCF), and served on the Board of Directors of the Professional Photographers Society of Central Florida (PPSCF). In September of 1998, his studio was nominated "Small Business of the Year" by the Seminole Chamber of Commerce. **KATHLEEN HAWKINS** served as university professor and career placement director, and sits on

the Board of Directors as President of the Wedding Professionals of Central Florida (WPCF). She is also the Associate Chair of the National Association of Catering Executives (NACE).

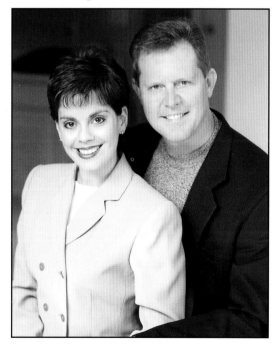

INDEX

Other Books from
Amherst Media™

Wedding Photographer's Handbook

Robert and Sheila Hurth

A complete step-by-step guide to succeeding in the world of wedding photography. Packed with shooting tips, equipment lists, must-get photo lists, business strategies, and much more! $29.95 list, 8½x11, 176p, index, 100 b&w and color photos, diagrams, order no. 1485.

Achieving the Ultimate Image

Ernst Wildi

Ernst Wildi teaches the techniques required to take world class, technically flawless photos. Features: exposure, metering, the Zone System, composition, evaluating an image, and more! $29.95 list, 8½x11, 128p, 120 b&w and color photos, index, order no. 1628.

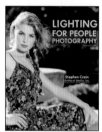

Lighting for People Photography, *2nd Edition*

Stephen Crain

The up-to-date guide to lighting. Includes: set-ups, equipment information, strobe and natural lighting, and much more! Features diagrams, illustrations, and exercises for practicing the techniques discussed in each chapter. $29.95 list, 8½x11, 120p, 80 b&w and color photos, glossary, index, order no. 1296.

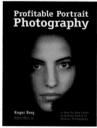

Profitable Portrait Photography

Roger Berg

A step-by-step guide to making money in portrait photography. Combines information on portrait photography with detailed business plans to form a comprehensive manual for starting or improving your business. $29.95 list, 8½x11, 104p, 100 photos, index, order no. 1570

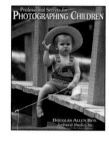

Wedding Photography:
Creative Techniques for Lighting and Posing, *2nd Edition*

Rick Ferro

Creative techniques for lighting and posing wedding portraits that will set your work apart from the competition. Covers every phase of wedding photography. $29.95 list, 8½x11, 128p, full color photos, index, order no. 1649.

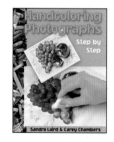

Professional Secrets for Photographing Children

Douglas Allen Box

Covers every aspect of photographing children on location and in the studio. Prepare children and parents for the shoot, select the right clothes capture a child's personality, and shoot story book themes. $29.95 list, 8½x11, 128p, 74 photos, index, order no. 1635.

Lighting Techniques for Photographers

Norman Kerr

This book teaches you to predict the effects of light in the final image. It covers the interplay of light qualities, as well as color compensation and manipulation of light and shadow. $29.95 list, 8½x11, 120p, 150+ color and b&w photos, index, order no. 1564.

Handcoloring Photographs Step-by-Step

Sandra Laird & Carey Chambers

The new standard in handcoloring reference books. Covers a variety of coloring media and techniques with plenty of colorful photographic examples. $29.95 list, 8½x11, 112p, 100+ color and b&w photos, order no. 1543.

Infrared Photography Handbook

Laurie White

Covers black and white infrared photography: focus, lenses, film loading, film speed rating, batch testing, paper stocks, and filters. Black & white photos illustrate how IR film reacts. $29.95 list, 8½x11, 104p, 50 b&w photos, charts & diagrams, order no. 1419.

Family Portrait Photography

Helen Boursier

Learn from professionals how to operate a successful portrait studio. Includes: marketing family portraits, advertising, working with clients, posing, lighting, and selection of equipment. Includes images from a variety of top portrait shooters. $29.95 list, 8½x11, 120p, 123 photos, index, order no. 1629.

The Art of Infrared Photography, 4th Edition

Joe Paduano

A practical guide to the art of infrared photography. Tells what to expect and how to control results. Includes: anticipating effects, color infrared, digital infrared, using filters, focusing, developing, printing, handcoloring, toning, and more! $29.95 list, 8½x11, 112p, 70 photos, order no. 1052

The Art of Portrait Photography

Michael Grecco

Michael Grecco reveals the secrets behind his dramatic portraits which have appeared in magazines such as *Rolling Stone* and *Entertainment Weekly*. Includes: lighting, posing, creative development, and more! $29.95 list, 8½x11, 128p, 60 photos, order no. 1651.

Photographer's Guide to Polaroid Transfer

Christopher Grey

Step-by-step instructions make it easy to master Polaroid transfer and emulsion lift-off techniques and add new dimensions to your photographic imaging. Fully illustrated every step of the way to ensure good results the very first time! $29.95 list, 8½x11, 128p, 50 photos, order no. 1653.

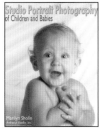

Wedding Photojournalism

Andy Marcus

Learn the art of creating dramatic unposed wedding portraits. Working through the wedding from start to finish you'll learn where to be, what to look for and how to capture it on film. A hot technique for contemporary wedding albums! $29.95 list, 8½x11, 128p, b&w, over 50 photos, order no. 1656.

Studio Portrait Photography of Children and Babies

Marilyn Sholin

Learn to work with the youngest portrait clients to create images that will be treasured for years to come. Includes tips for working with kids at every developmental stage, from infant to pre-schooler. Features: lighting, posing and much more! $29.95 list, 8½x11, 128p, 60 photos, order no. 1657.

Professional Secrets of Wedding Photography

Douglas Allen Box

Over fifty top-quality portraits are individually analyzed to teach you the art of professional wedding portraiture. Lighting diagrams, posing information and technical specs are included for every image. $29.95 list, 8½x11, 128p, order no. 1658.

Photographer's Guide to Shooting Model & Actor Portfolios

CJ Elfont, Edna Elfont and Alan Lowy

Create outstanding images for actors and models looking for work in fashion, theater, television, or the big screen. Includes business, photographic and professional information! $29.95 list, 8½x11, 128p, 100 photos, order no. 1659.

Photo Retouching with Adobe® Photoshop®

Gwen Lute

Designed for photographers, this manual teaches every phase of the process, from scanning to final output. Learn to restore damaged photos, correct imperfections, create realistic composite images and correct for dazzling color. $29.95 list, 8½x11, 120p, 60+ photos, order no. 1660.

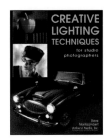

Creative Lighting Techniques for Studio Photographers

Dave Montizambert

Master studio lighting and gain complete creative control over your images. Whether you are shooting portraits, cars, table-top or any other subject, Dave Montizambert teaches you the skills you need to confidently create with light. $29.95 list, 8½x11, 120p, 80+ photos, order no. 1666.

Storytelling Wedding Photography

Barbara Box

Barbara and her husband shoot as a team at weddings. Here, she shows you how to create outstanding candids (which are her specialty), and combine them with formal portraits (her husband's specialty) to create a unique wedding album. $29.95 list, 8½x11, 128p, 60 b&w photos, order no. 1667.

Marketing and Selling Black & White Portrait Photography

Helen T. Boursier

Complete manual for marketing b&w portraits. Learn how to attract clients and deliver the portraits that will keep them coming back. $29.95 list, 8½x11, 128p, 50+ photos, order no. 1677.

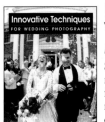

Innovative Techniques for Wedding Photography

David Neil Arndt

Spice up your wedding photography (and attract new clients) with dozens of creative techniques from top-notch professional wedding photographers! $29.95 list, 8½x11, 120p, 60 photos, order no. 1684.

Portrait Photographer's Handbook

Bill Hurter

Bill Hurter has compiled a step-by-step guide to portraiture that easily leads the reader through all phases of portrait photography. This book will be an asset to experienced photographers and beginners alike. $29.95 list, 8½x11, 128p, full color, 60 photos, order no. 1708.

Basic Scanning Guide For Photographers and Creative Types

Rob Sheppard

This how-to manual is an easy-to-read, hands on workbook that offers practical knowledge of scanning. It also includes excellent sections on the mechanics of scanning and scanner selection. $17.95 list, 8½x11, 96p, 80 photos, order no. 1702.

How to Buy and Sell Used Cameras

David Neil Arndt

Learn the skills you need to evaluate the cosmetic and mechanical condition of used cameras, and buy or sell them for the best price possible. Also learn the best places to buy/sell and how to find the equipment you want. $19.95 list, 8½x11, 112p, b&w, 60 photos, order no. 1703.

Basic Digital Photography

Ron Eggers

Step-by-step text and clear explanations teach you how to select and use all types of digital cameras. Learn all the basics with no-nonsense, easy to follow text designed to bring even true novices up to speed quickly and easily. $17.95 list, 8½x11, 80p, 40 b&w photos, order no. 1701.

Posing and Lighting Techniques for Studio Photographers

J.J. Allen

Master the skills you need to create beautiful lighting for portraits of any subject. Posing techniques for flattering, classic images help turn every portrait into a work of art. $29.95 list, 8½x11, 120p, 125 fullcolor photos, order no. 1697.

Studio Portrait Photography in Black & White

David Derex

From concept to presentation, you'll learn how to select clothes, create beautiful lighting, prop and pose top-quality black & white portraits in the studio. $29.95 list, 8½x11, 128p, 70 photos, order no. 1689.

Watercolor Portrait Photography: The Art of Manipulating Polaroid SX-70 Images

Helen T. Boursier

Create one-of-a-kind images with this surprisingly easy artistic technique. $29.95 list, 8½x11, 120p, 200+ color photos, order no. 1698.

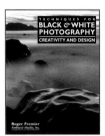

Techniques for Black & White Photography: Creativity and Design

Roger Fremier

Improve your photographic design with these techniques and exercises. From shooting to editing your results, it's a complete course for photographers who want to be more creative. $19.95 list, 8½x11, 112p, 30 photos, order no. 1703.

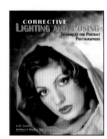

Corrective Lighting and Posing Techniques for Portrait Photographers

Jeff Smith

Learn to make every client look his or her best by using lighting and posing to conceal real or imagined flaws – from baldness, to acne, to figure flaws. $29.95 list, 8½x11, 120p, full color, 150 photos, order no. 1711.